A Photo Tour of the Twin Cities

MINNEAPOLIS ST. PAUL

2ND EDITION

by Gregg Felsen

ADVENTURE PUBLICATIONS
Cambridge, Minnesota

DEDICATION

This book is dedicated to all the residents and visitors to Minneapolis and Saint Paul who, like me, love the natural beauty of the area throughout the four seasons as well as the multitude of museums, theaters, restaurants, festivals, historic buildings and neighborhoods, professional sporting events, outdoor recreational venues, and attractions in the Twin Cities.

CREDITS

All photos by Gregg Felsen

Cover photos: Stone Arch Bridge, Minneapolis (*front, top*); CHS Field, St. Paul (*front, bottom*); St. Paul skyline (*back, top*); sailing on Lake Harriet (*back, middle*)

Cover and book design by Jonathan Norberg

10 9 8 7 6 5 4 3 2 1

First Edition 2008
Second Edition 2017
Copyright 2017 by Gregg Felsen
Published by Adventure Publications
An imprint of AdventureKEEN
820 Cleveland Street South
Cambridge, Minnesota 55008
(800) 678-7006
www.adventurepublications.net
Printed in China
ISBN: 978-1-59193-552-0; eISBN: 978-1-59193-572-8

A Photo Tour of the Twin Cities

MINNEAPOLIS ST. PAUL

2ND EDITION

INTRODUCTION

The Minneapolis-Saint Paul metropolitan area is considered the Midwest's cultural, entertainment, and commercial capital. Despite being widely known for its bone-chilling winter weather, the Twin Cities is one of the most livable, vibrant, diverse, and beautiful communities in the United States. St. Paul, the state capital, has been likened to a European city with its quaint neighborhoods and a large collection of well-preserved Victorian buildings, while Minneapolis, the larger and slightly younger of the two cities, boasts an impressive skyline with modern skyscrapers.

The seven-county area boasts a system of regional parks and trails that are nationally renowned for their beauty, size, and the variety of amenities they offer. With 54 parks and more than 340 miles of interconnected trails, the system provides a wealth of year-round recreational opportunities. Favorites include Theodore Wirth, Minnehaha, and Loring parks in Minneapolis, and Rice, Como, and Mears parks in St. Paul.

Recently, Minneapolis and St. Paul were connected by a rail line for the first time in six decades. Metro Transit's Green Line and Blue Line light rail system makes it easy and economical to travel between downtown Minneapolis and downtown St. Paul and to the Mall of America, Target Field, and Minneapolis/St. Paul International Airport.

The Twin Cities is home to one of the largest public research universities in the country as well as a long list of prestigious private educational institutions. The area is also a mecca for medical device, technology, and biotech companies, including Medtronic, 3M, St. Jude Medical, and Boston Scientific.

Summer, fall, winter or spring, there is always something to do in Minneapolis and St. Paul. Whether your interests are music, museums, theater, restaurants, sports, history, hip nightlife, or quiet places to enjoy nature, the Twin Cities offer something for everyone.

For more information about the venues included in this book as well as a selection of Minnesota-made products; information about mass transit and other transportation services; and for answers to questions and recommendations about things to do in the Twin Cities, visit Minneapolis Visitor Information on Nicollet at 505 Nicollet Mall, Suite 100, or call 612-397-9275.

FASCINATING FACTS ABOUT THE TWIN CITIES

- The 7-county Twin Cities metropolitan area encompasses approximately 3.2 million people and 218 cities and townships; altogether, it's the 16th-largest metropolitan area in the country.

- Minneapolis and St. Paul are not "identical twins." With its heavy influence of late-Victorian architecture, St. Paul is considered the last of the country's eastern cities. Minneapolis has been called the first city of the American West for its broad boulevards, grid-like layout, and modern architecture.

- Minneapolis-St. Paul is a destination for sports fanatics. Altogether, the metro area boasts six professional sports teams: The Minnesota Vikings play in the National Football League; their home field is the awe-inspiring U.S. Bank Stadium, which dominates the Minneapolis skyline. The Minnesota Twins play Major League Baseball games at the open-air Target Field, and the Minnesota Timberwolves tip off against their National Basketball Association opponents just next door at the Target Center. If it's hockey you're after, The Minnesota Wild face off against National Hockey League teams at the Xcel Energy Center in St. Paul. And then there's the Minnesota Lynx, a perennial power in the Women's National Basketball Association. The area's newest pro club is Minnesota United, which plays which plays in Major League Soccer, the top-tier of U.S. soccer.

- While the Mississippi River is the Twin Cities' most famous waterway, it is only part of the story. There are approximately 1,003 lakes in the 7-county metro area, along with other scenic rivers such as the Minnesota, Rum, and St. Croix.

- Summer brings an average of 13 days in the 90s. Winter usually delivers 24 days with below-zero temperatures. A typical July day sees a high of 83 and low of 64. In January, the average dips to a high of 23 and low of 7 degrees. On average, the Twin Cities receives about 45 inches of snowfall each year.

- If you visit in the winter, you often don't need to venture outside, though. Both Minneapolis and St. Paul have extensive skyway systems, which are appreciated by all in the winter. The Minneapolis system spans 11 miles, allowing access to 69 blocks. St. Paul's covers 5 miles, linking nearly every downtown building.

- Popular with locals and tourists alike, the Mall of America, located in Bloomington, Minnesota, is the biggest indoor shopping mall in America. It is home to 400 stores, a 7-acre theme park, and a 1.2-million-gallon aquarium.

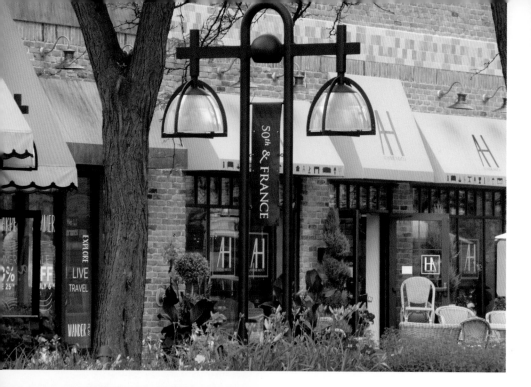

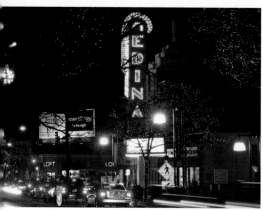

50ᵗʰ & FRANCE

This upscale downtown Edina business neighborhood offers a diverse mix of over 175 businesses, including boutiques, specialty stores, restaurants, salons and spas as well as clothing stores, and a historic theater that screens new releases and foreign films. The Edina Art Fair, held in June, is one of the best in Minnesota.

ALEXANDER RAMSEY HOUSE

Built by Minnesota's first territorial governor (and second governor), Alexander Ramsey, this 15-room house is one of the best-preserved Victorian-era homes in America. Located in the Irving Park Historic District in St. Paul, it hosts special events and lectures and offers tours year-round.

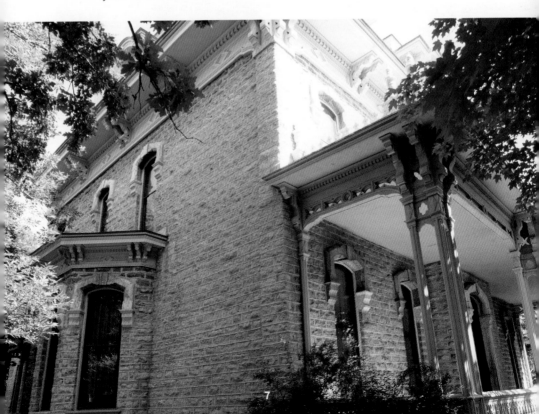

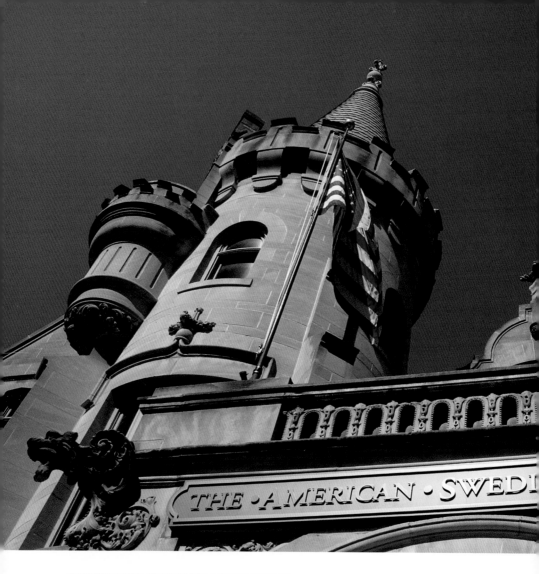

AMERICAN SWEDISH INSTITUTE

This elaborate, 33-room French Châteauesque-style mansion is home to the American Swedish Institute, the largest museum of Swedish-American culture in the United States. Swedish immigrant and newspaper publisher Swan J. Turnblad built the house at the turn of the century and founded the institute in 1929.

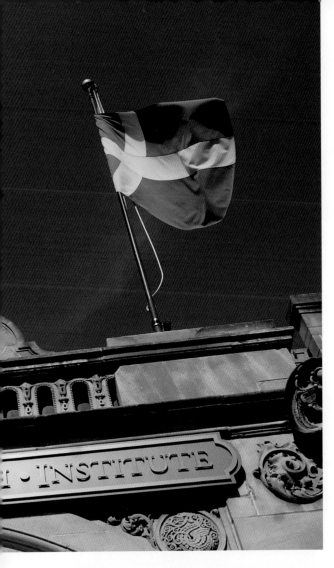

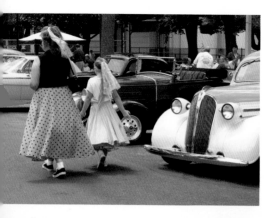

BACK TO THE 50s

Sponsored by the Minnesota Street Rod Association since 1974 and held at the Minnesota State Fairgrounds, this annual 3-day affair every June features nearly 12,000 vintage vehicles and attracts over 125,000 spectators. It is the largest 3-day car show of its kind in the world.

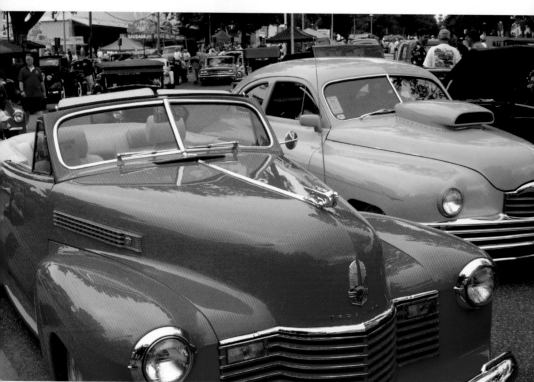

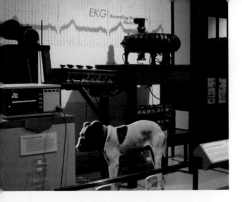

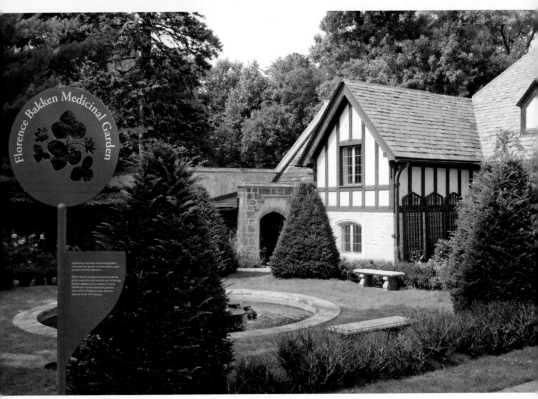

THE BAKKEN

Located in an English Tudor mansion on the west shore of Lake Calhoun, The Bakken was founded in 1975 by Medtronic co-founder, Earl Bakken, who was also inventor of the first external cardiac pacemaker. The museum, complete with many interactive displays, is devoted to explaining the historical role of electricity and magnetism in life sciences and medicine. Exhibits include the popular multimedia display about Frankenstein, who created his famous monster with electricity.

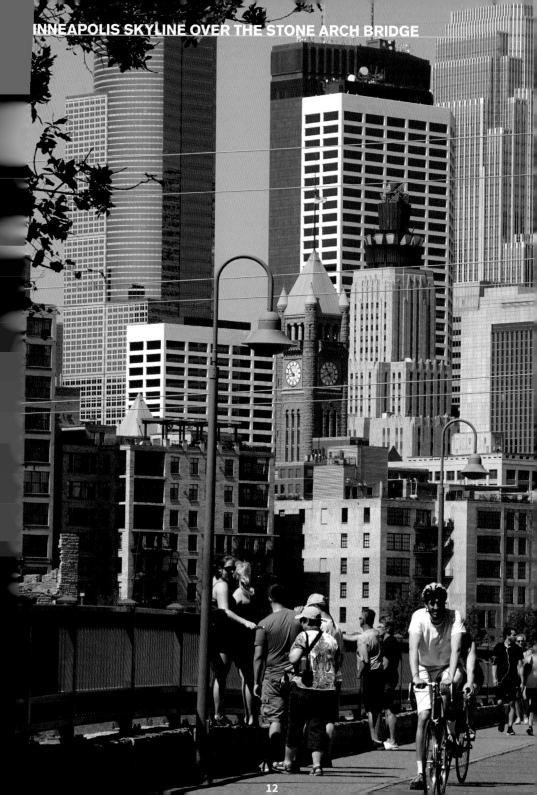

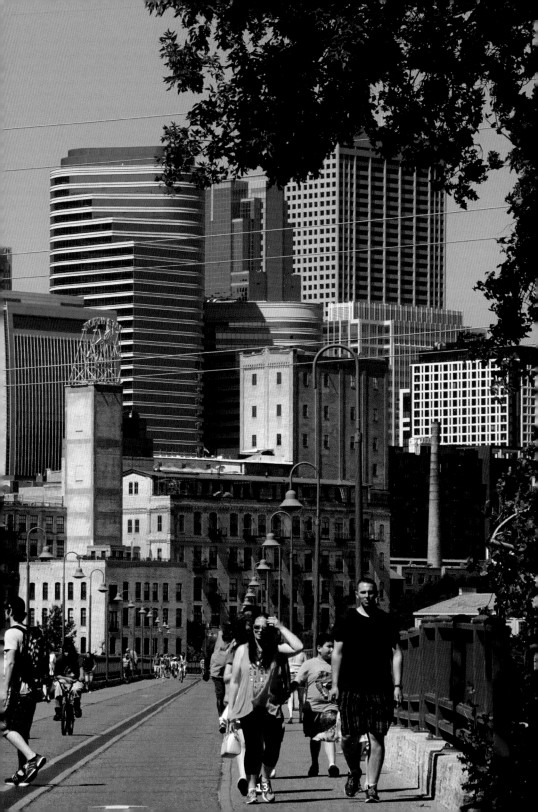

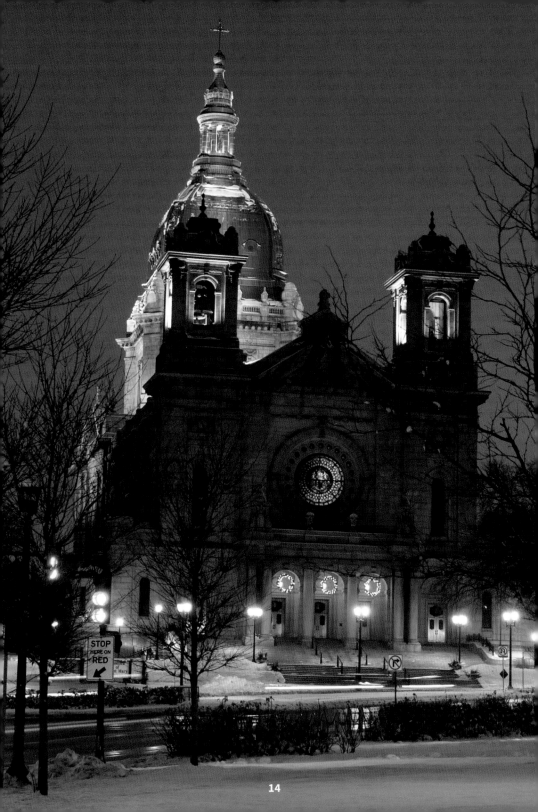

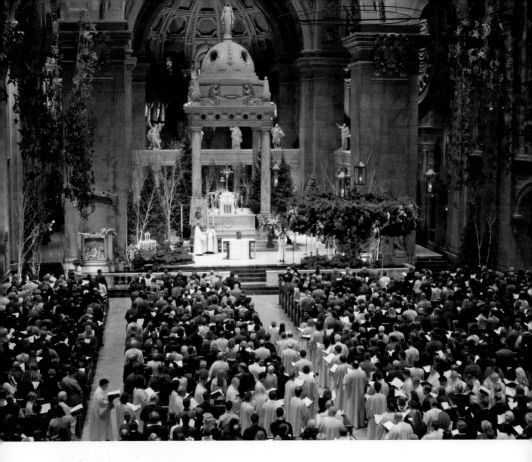

BASILICA OF ST. MARY

This masterpiece of Beaux Arts architecture was the
vision of Archbishop John Ireland and French architect
Emmanuel Masqueray. After eight years of construction
that began in 1907, the first mass was held in 1914.
Pope Pius XI declared the building the first Basilica in
America in 1926.

It features a cavernous 82-foot by 140-foot nave and
60 stained glass windows.

BIKING

Among the many popular bicycle routes in the Twin Cities are the Gateway Trail, the Minneapolis Grand Rounds and the Luce Line Trail. The 18-mile Gateway Trail runs from St. Paul to Stillwater. As one of only four urban national scenic byways, the 50-mile Minneapolis Grand Rounds curves through the heart of the city. The 63-mile Luce Line Trail travels along mixed-surface trails from Plymouth to west-central Minnesota.

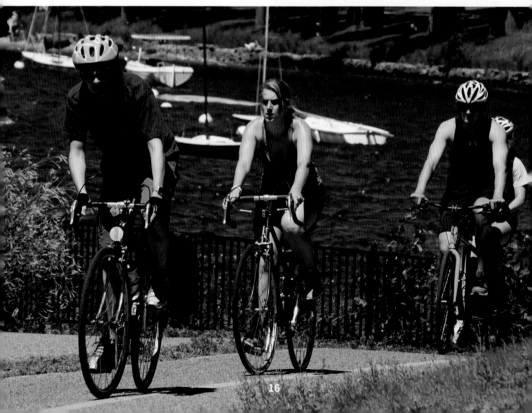

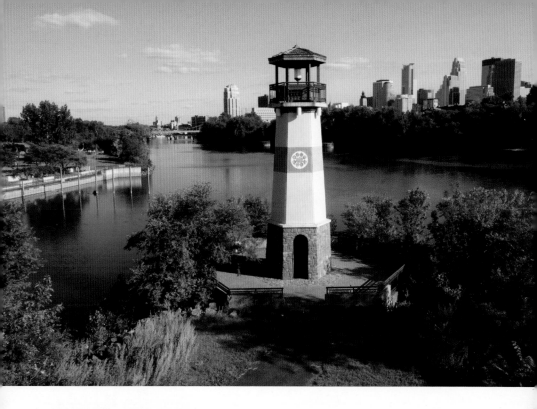

BOOM ISLAND PARK

Part of the historic Mississippi Riverfront District, this 22-acre tranquil riverfront park includes a boat dock, a playground, walking paths, reservable picnic areas, and a lovely promenade often used for weddings. There's even a miniature lighthouse, and a stunning view of the Minneapolis skyline.

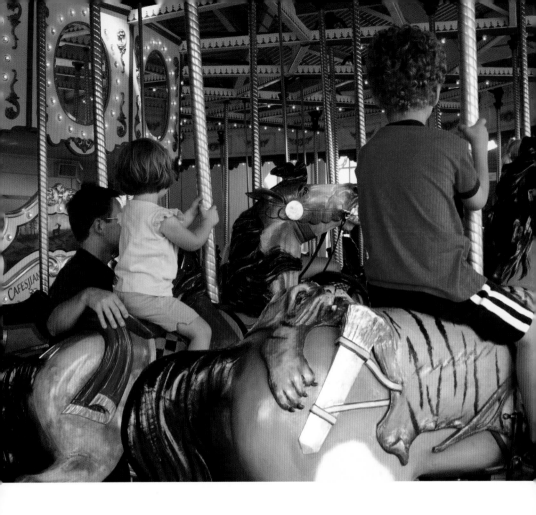

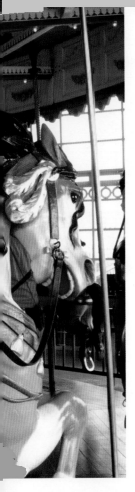

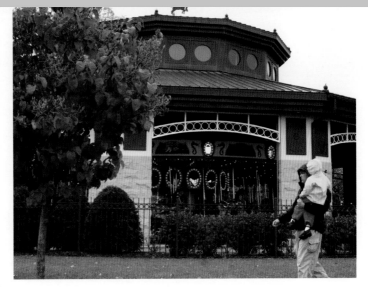

CAFESJIAN'S CAROUSEL

For more than 75 years, this colorful, hand-carved wooden carousel was a beloved Minnesota State Fair attraction. Once on the verge of being auctioned off, former West Publishing owner and philanthropist Gerard L. Cafesjian financially led the charge to purchase and restore the old ride, which is now located at St. Paul's Como Park.

CANTERBURY PARK ➤

One of the premier live Thoroughbred and Quarter Horse racing venues in the United States, Canterbury Park's racing season runs from mid-May through mid-September. Canterbury Park also features an expansive area for casino table games, daily simulcasts of races at tracks throughout the country, and it is a versatile multipurpose event center for galas, trade shows, corporate events, and concerts.

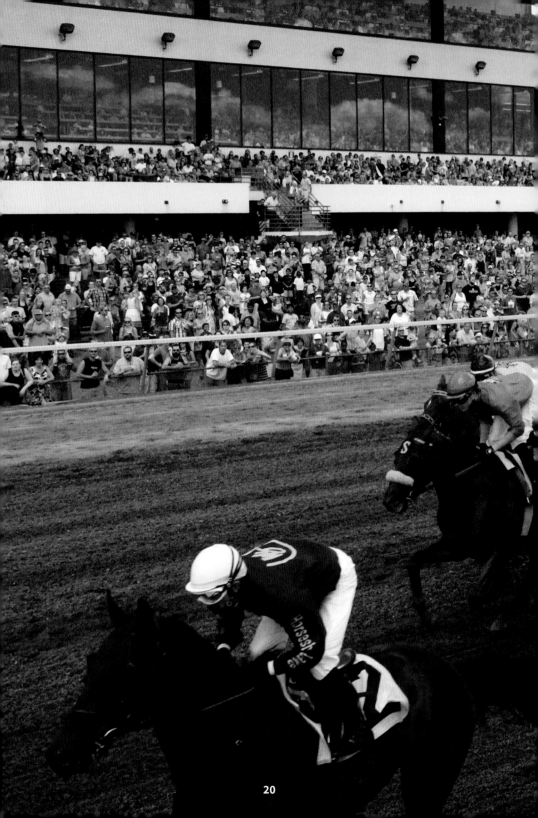

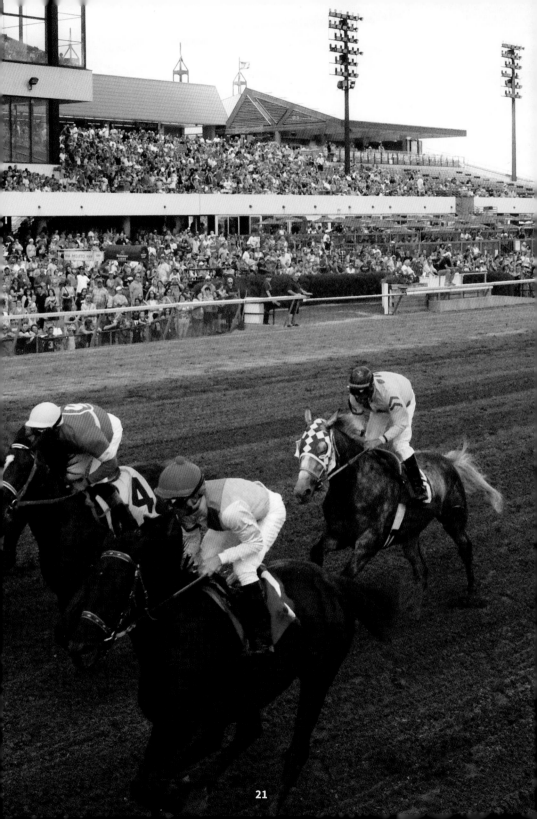

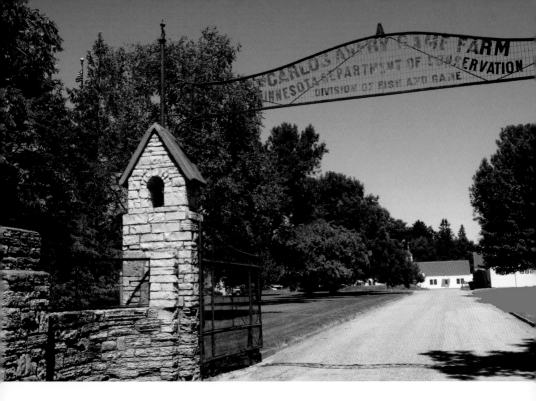

CARLOS AVERY WILDLIFE MANAGEMENT AREA

Named for Minnesota's first conservation commissioner, Carlos Avery covers nearly 25,000 acres of wildlife habitat in Anoka and Chisago counties. The area attracts some 270 bird species, including great blue herons, Canadian geese, sandhill cranes, wild swans, and various birds of prey. Public hunting and trapping is allowed in sections of the area.

CATHEDRAL OF ST. PAUL

Located on the highest point in downtown St. Paul, this is the mother church of the Roman Catholic Archdiocese of Minneapolis and St. Paul and was modeled after St. Peter's Basilica in Rome. It celebrated its first mass in 1915. The cathedral features 6 chapels, seats 3,000 people, features a 120-foot-wide dome, and is an incredible 306 feet tall. It was added to the National Register of Historic Places in 1974.

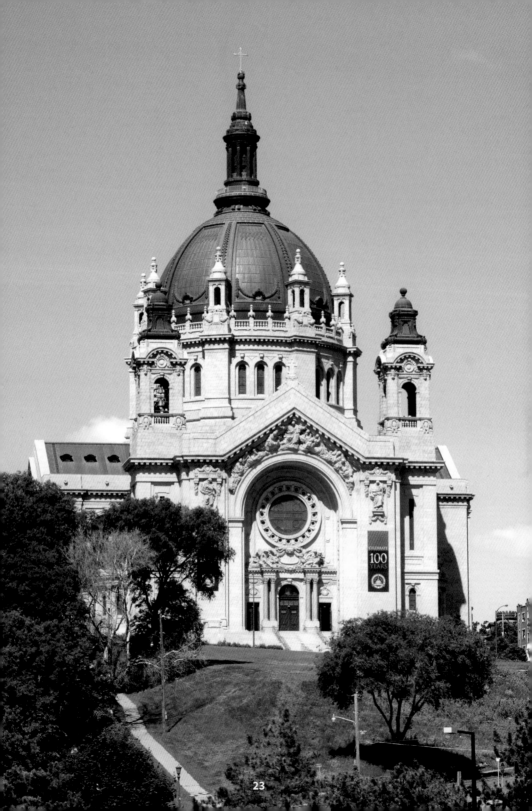

CHANHASSEN DINNER THEATRES

Since it opened on October 11, 1968, over 12 million guests have attended productions at the theatre, which is the largest professional dinner theatre in the country. With four stages in all, it's famous for its fine food and productions including the likes of *Grease*, *Camelot*, and more.

CHILDREN'S THEATRE COMPANY

Established in 1965, this Tony Award-winning theatre company offers extraordinary experiences that educate, challenge, and inspire children and families. Since its inception, more than 11 million people have attended its 200-plus plays. Today, the Children's Theatre Company is recognized as North America's flagship theatre for young people and families.

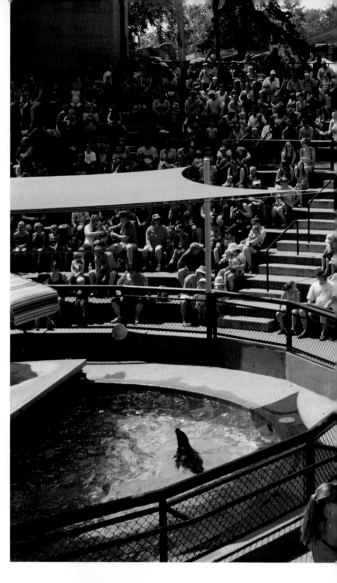

COMO PARK ZOO

Open 365 days a year and with no admission charge (though donations are recommended), the Como Park Zoo is one of the top destinations in Minnesota, attracting 1.8 million visitors annually. Established in 1897, the zoo features a variety of animal habitats including the hugely popular Polar Bear Odyssey, Gorilla Forest, Giraffe Feeding Station, and the famous show involving Sparky the Sea Lion.

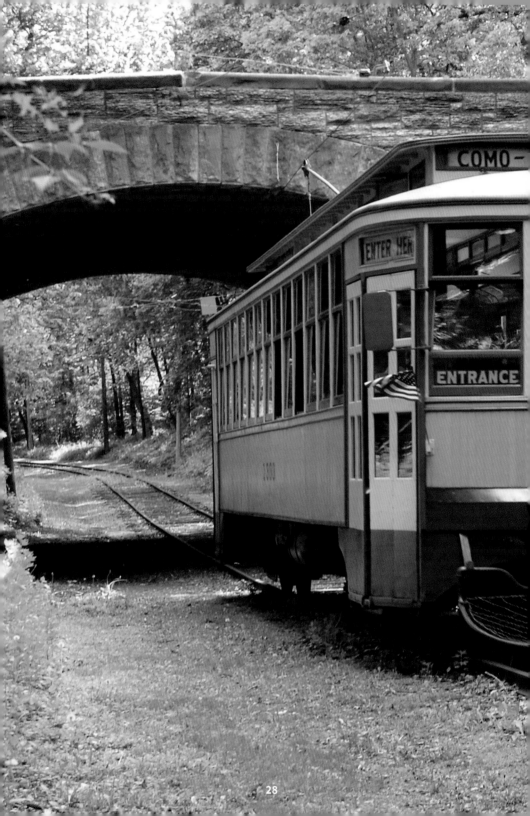

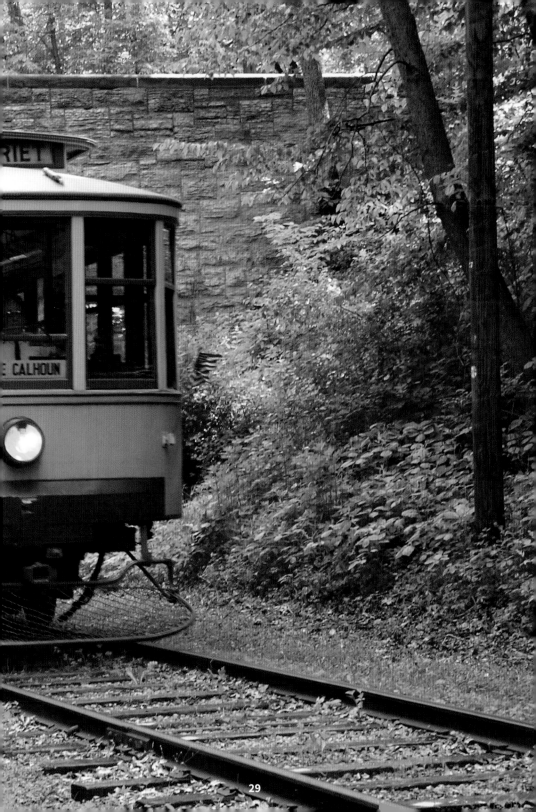

Passengers can enjoy a ride back in time aboard three restored 100-year-old electric streetcars that travel along a 1.5-mile track from the Linden Hills Station on the west side of Lake Harriet to the southeast shore of Lake Calhoun. Trolleys run from May through October with the schedule changing seasonally.

ELOISE BUTLER WILDFLOWER GARDEN AND BIRD SANCTUARY

Open from April 1 to October 15 and occupying 15 acres of woodland, wetland, and prairie habitats, this is the oldest public wildflower garden in the United States. Founded in 1907 at the urging of botany teacher Eloise Butler, the garden is located just 3 miles west of downtown Minneapolis and is home to 500 varieties of native plants and wildflowers. More than 130 bird species visit the garden or reside in it, and 60,000 people enjoy its beauty annually.

FIRST AVENUE

One of the top rock music venues in America, First Avenue occupies the building in downtown Minneapolis that was originally built in 1937 as an Art Deco-themed Northland Greyhound Depot. After Greyhound moved out, the building was purchased by Allan Fingerhut, and the club opened on April 3, 1970, with a sold-out concert by Joe Cocker. Performers at the club are commemorated by silver stars on the building's wall; there you can find the likes of B.B. King, Rod Stewart, R.E.M., Paul Simon, Soul Asylum, Ray Charles, Bo Diddley, and many others. First Avenue is famous for its long ties to Prince, whose inaugural performance at First Avenue took place on March 9, 1981, and much of the film *Purple Rain* was filmed at First Avenue in December 1983. The venue continues to host some of the most famous acts in music today.

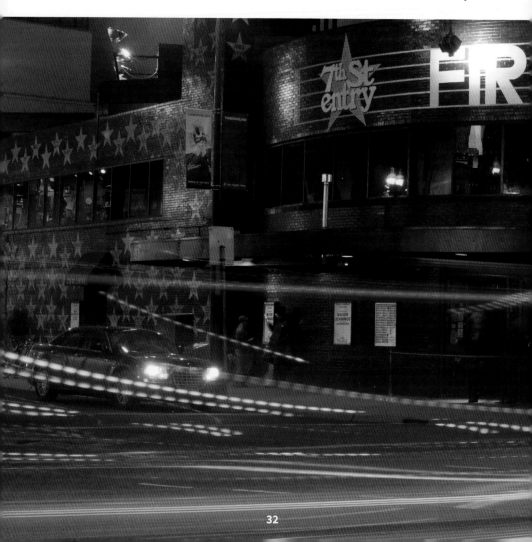

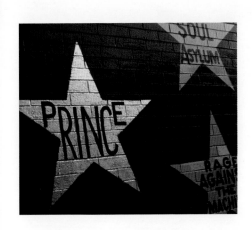

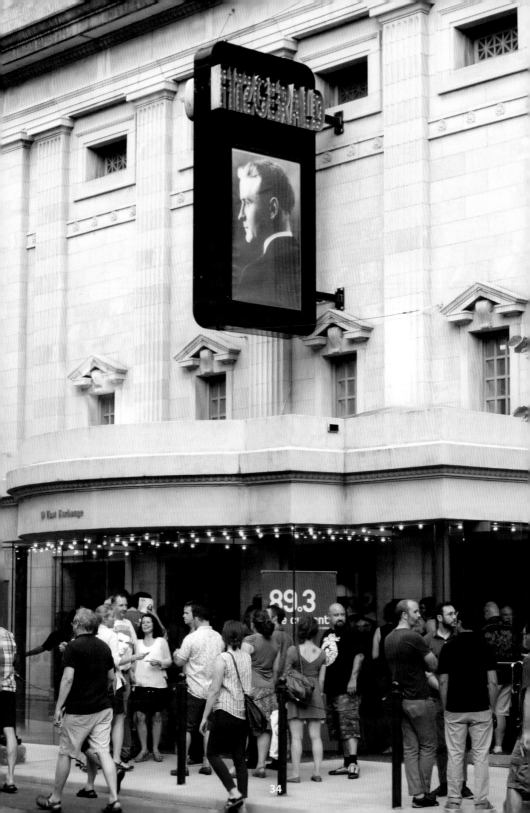

FITZGERALD THEATER

Built in 1910 and St. Paul's oldest surviving theater, this 1,058-seat theater boasts a 2-story balcony and near-perfect acoustics and sight lines. It is named after St. Paul native novelist and short story writer F. Scott Fitzgerald, who is best known for his novel *The Great Gatsby*. The theater is home to the weekly radio broadcast of *A Prairie Home Companion*.

FORT SNELLING NATIONAL CEMETERY ➤

Established in 1870 as a burial ground for soldiers stationed at the fort, it was dedicated as a national cemetery in 1939. Administered by the United States Department of Veterans Affairs, the cemetery currently encompasses 436 acres, and as of 2016 had 221,000 interments, including several Medal of Honor recipients and many notable figures from Minnesota and U.S. history.

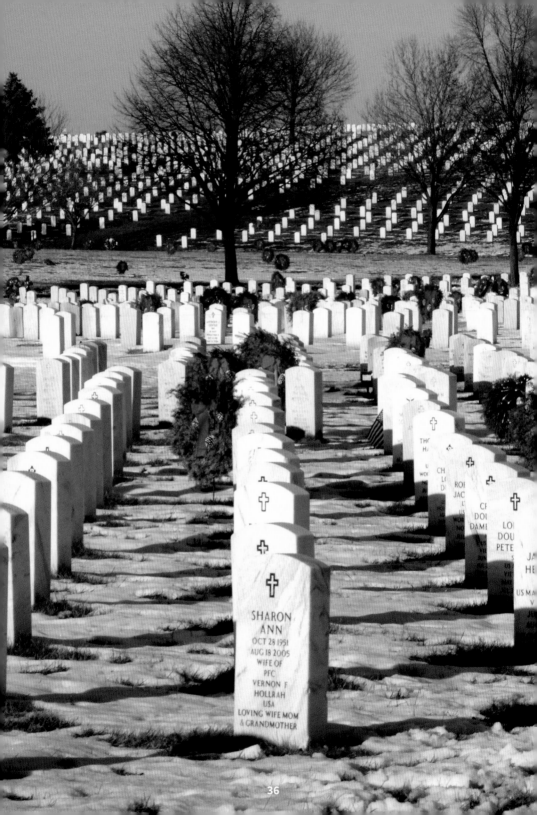

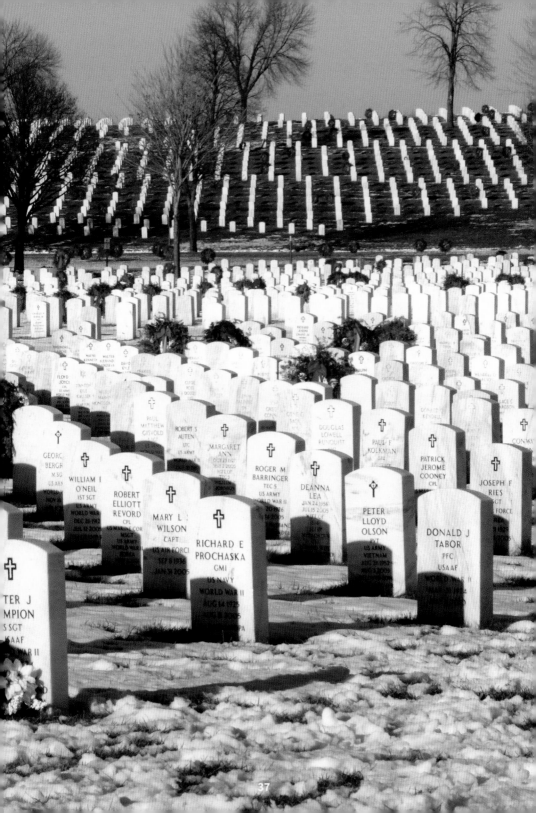

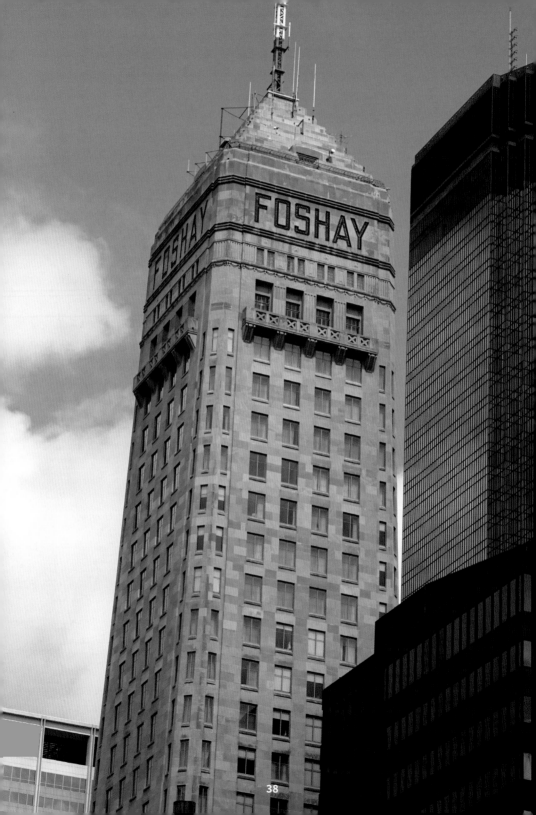

FOSHAY TOWER

Modeled after the Washington Monument and the first skyscraper west of the Mississippi River, the 32-story Foshay Tower was completed in 1929 and remained the tallest building in Minneapolis until 1973. The office building became a hotel when it was converted to a luxury 230-room hotel in 2008. It is now known as the "W Minneapolis—The Foshay."

GOLFING

Minnesota has more golfers per capita than any other state in America, and there are more than 200 courses in the Twin Cities area. Numerous professional-amateur and professional tournaments have been held in the Twin Cities, including the 2016 Ryder Cup at Hazeltine National Golf Course in Chaska, which attracted more than 250,000 fans.

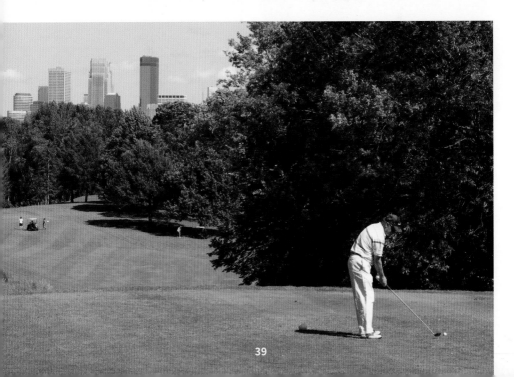

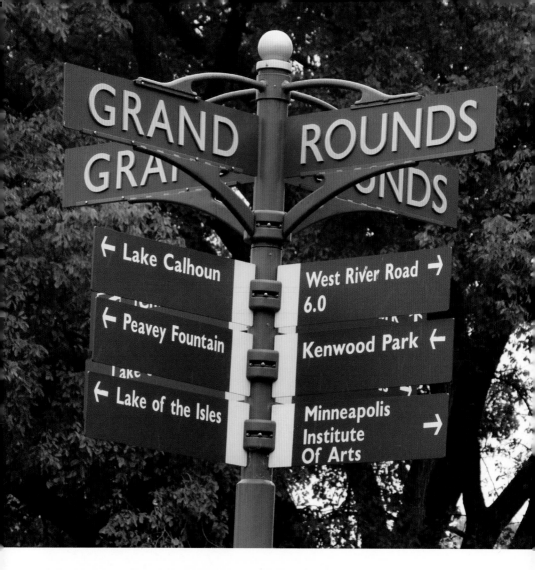

GRAND ROUNDS NATIONAL SCENIC BYWAY

The Grand Rounds is a 50-mile-long system of roadways, paths, and trails that encircles the city of Minneapolis. Divided into seven districts (Downtown Riverfront, Mississippi River, Minnehaha, Chain of Lakes, Theodore Wirth, Victory Memorial, and Northeast), the Grand Rounds is the country's longest continuous system of public urban parkways and passes by some of the city's most beautiful neighborhoods, lakes, waterfalls, churches, and museums.

GUTHRIE THEATER

Founded by English theater director, Sir Tyrone Guthrie, the theater opened on a May 7, 1963, with a production of *Hamlet*. The original theater on Vineland Place in the Kenwood neighborhood was replaced in 2006 with a distinctive $125 million building that features three theaters in all and is located in the historic Mill District along the Mississippi River.

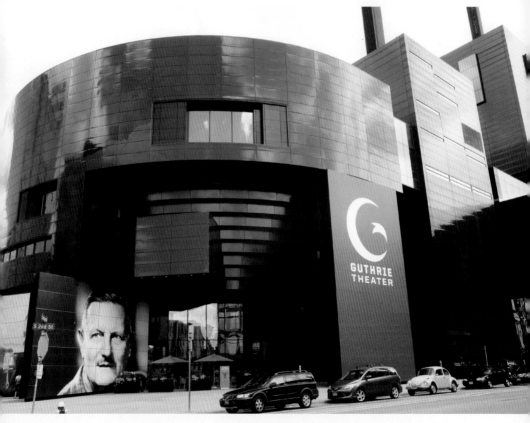

HARRIET ISLAND REGIONAL PARK

Named after temperance reformer and suffragette Harriet Bishop, St. Paul's first schoolteacher, Harriet Island was given to the city in 1900 as a public recreation area. Across the Wabasha Street Bridge from downtown St. Paul, the island includes the Moderne-style pavilion designed by Clarence W. Wigington, the country's first black municipal architect.

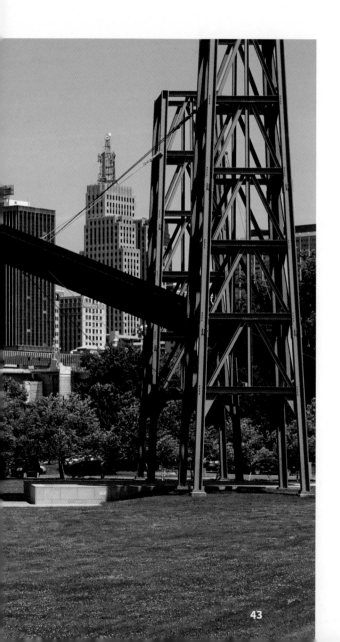

HISTORIC FORT SNELLING ➤

Built on a limestone bluff overlooking the confluence of the Mississippi and Minnesota rivers, Fort Snelling was built and activated in the 1820s. At the time, it was one of the U.S. Army's most isolated military outposts. Decommissioned in 1946, each year over 500,000 people visit the historic fort to see costumed guides and reenactors wearing period clothing and practicing military drills.

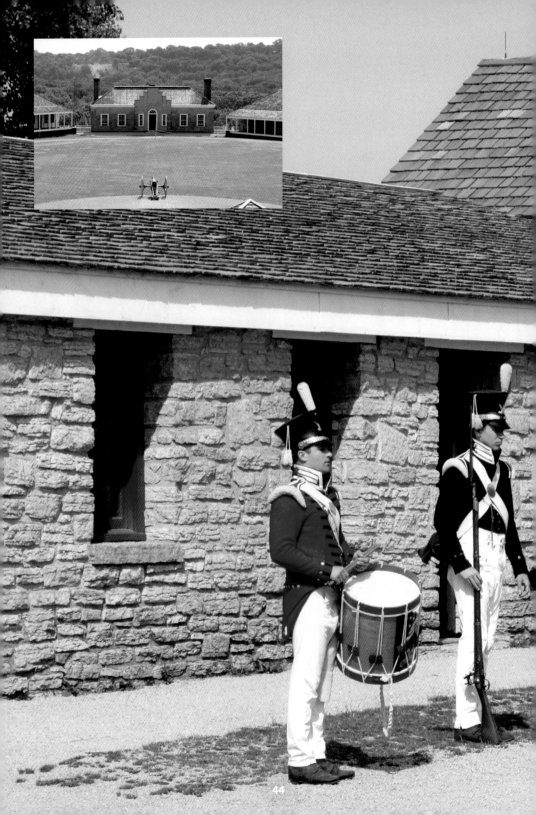

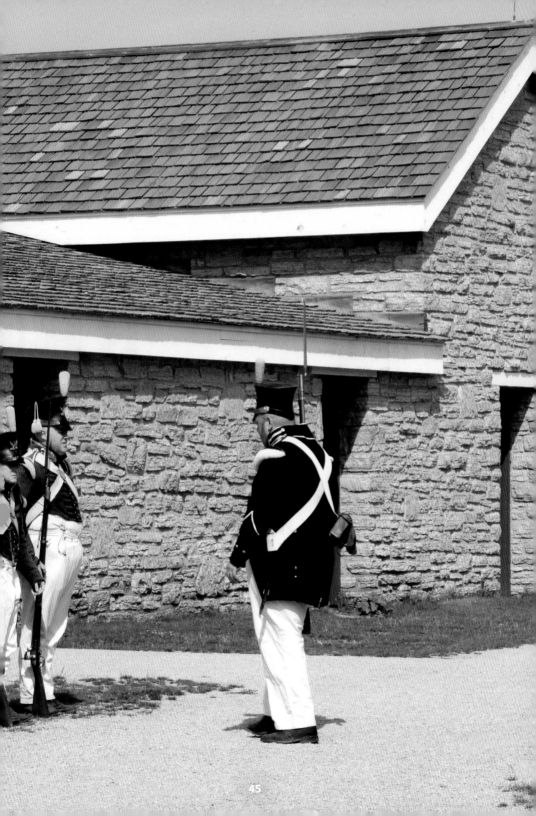

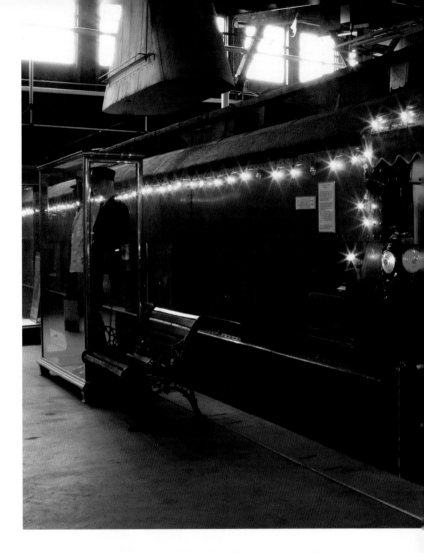

JACKSON STREET ROUNDHOUSE

The Jackson Street Roundhouse is the headquarters of the Minnesota Transportation Museum. The Roundhouse was built by James J. Hill in 1907 as a steam engine maintenance facility for the Great Northern Railway. Exhibits feature local and regional railway and mass transport history, with 50 historic train cars on-site. The museum also offers caboose and vintage bus rides, train simulators, and much more.

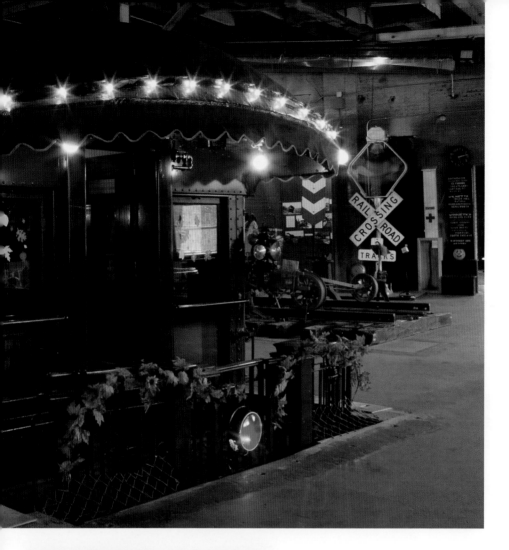

JAMES J. HILL HOUSE

Legendary railroad magnate James J. Hill's five-story mansion on Summit Avenue overlooks downtown St. Paul and the Mississippi River. Built to Hill's precise standards and completed in 1891, it was by far the largest house in the state. Even today, at 36,000 square feet, it's still massive. In all, it features 42 rooms, 22 fireplaces, and a whopping 16 glass chandeliers.

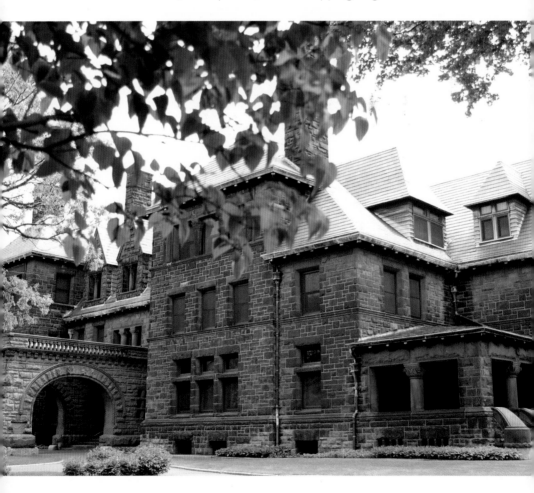

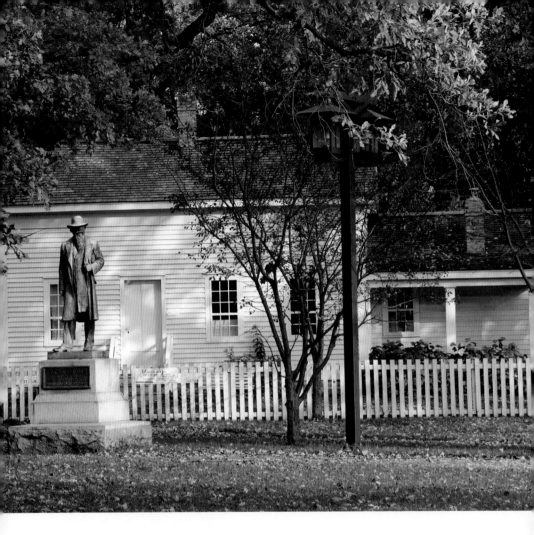

JOHN H. STEVENS HOUSE

Built in 1849, this simple wooden home became the hub of a new
city. This was the first frame house in the area, and it also served
as the city's first courthouse and one-room schoolhouse. It was
here that the name Minneapolis was chosen for the burgeoning
settlement; other contenders at the time were All Saints, Albion,
and Lowell.

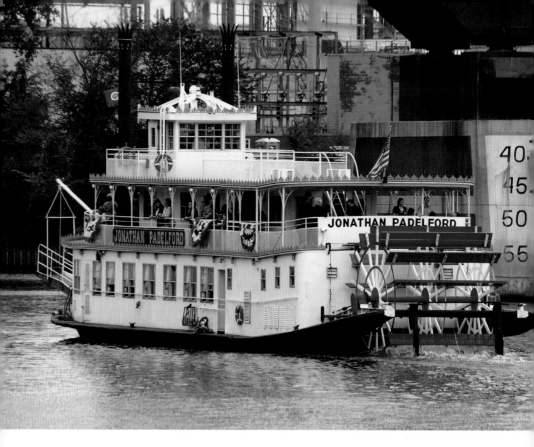

JONATHAN PADELFORD

One of the only authentic paddleboats currently operating on the Mississippi River, the 125-foot, 160-passenger, *Jonathan Padelford* is the flagship of 4 riverboats that offer sightseeing cruises on the river from mid-April through October. Cruises originate from Harriet Island Regional Park.

LAKE CALHOUN

Named for John C. Calhoun, who served as vice president for John Quincy Adams and Andrew Jackson, Lake Calhoun is the largest in the Minneapolis Chain of Lakes. Attractions and activities include three beaches, biking and walking trails, a public boat launch, nearby restaurants, and bike, kayak, and paddleboat rentals. It is also a popular lake for sailing, swimming, and in the winter, ice fishing.

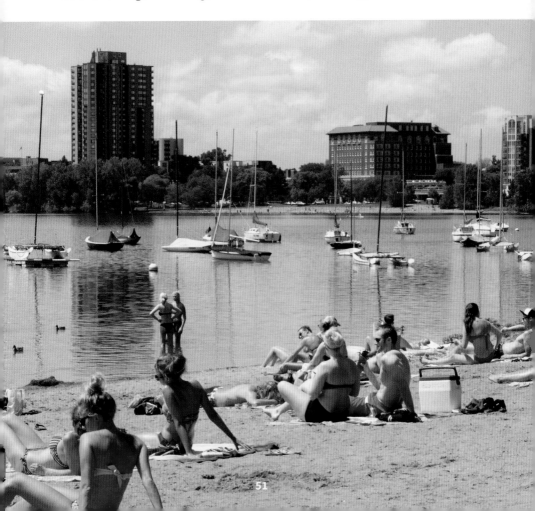

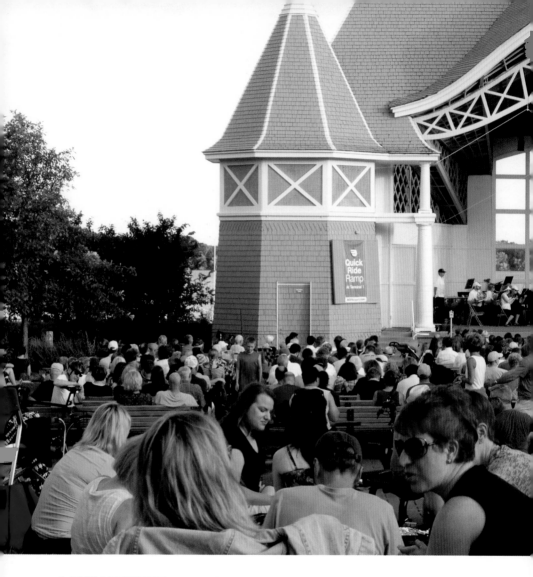

LAKE HARRIET

Lake Harriet is named after Harriet Lovejoy, the wife of American soldier Henry Leavenworth, Fort Snelling's first commander. The lake is popular with swimmers, walkers and runners, kayakers and canoeists, anglers, and bicyclists. The band shell on the north end of the lake features free daily musical concerts from the end of May through Labor Day, drawing tens of thousands of visitors over the course of the summer.

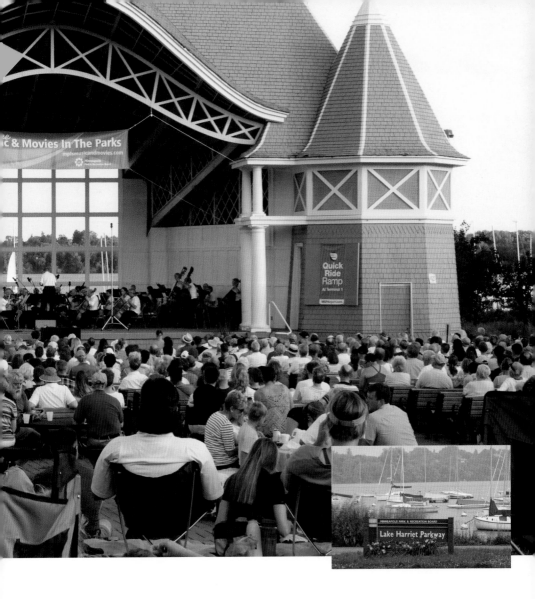

LAKE HARRIET-LYNDALE PARK ROSE GARDEN ➤

Designed by Theodore Wirth, father of the Minneapolis park system, this 1-acre garden was established in 1907–1908 and is the second-oldest public rose garden in America. (The other is in Connecticut and was also designed by Wirth.) The garden features over 4000 plants, 250 varieties of roses, and can contain upwards of 60,000 blooms in peak season.

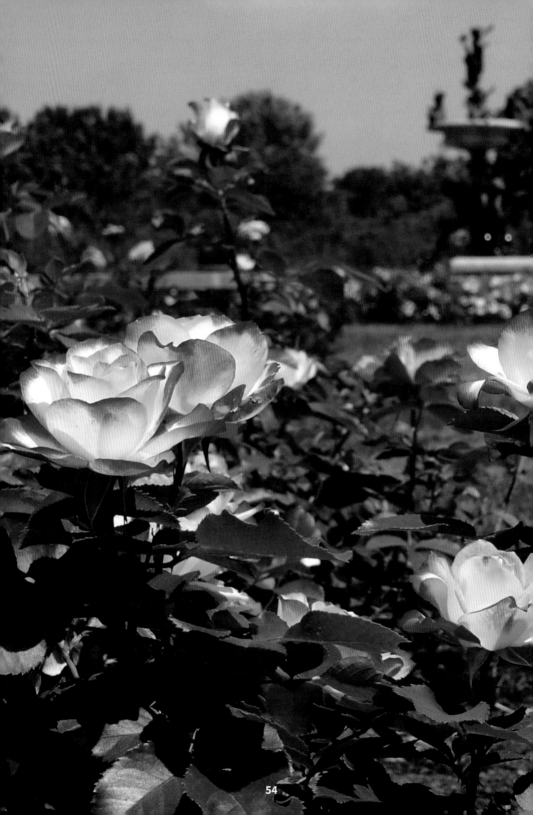

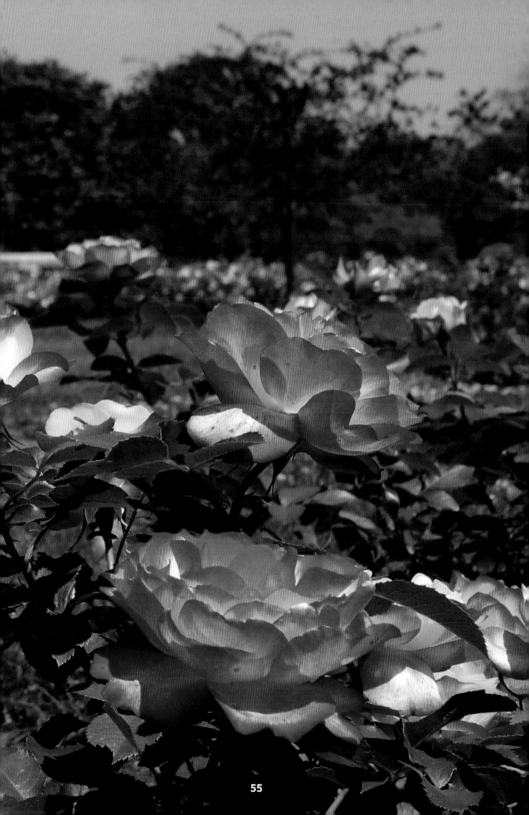

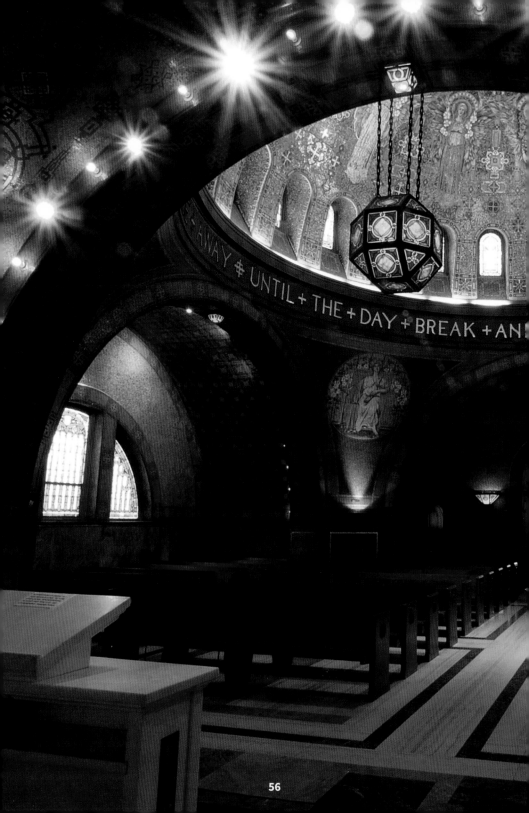

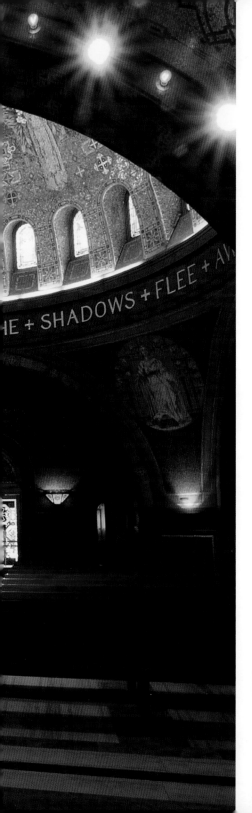

LAKEWOOD MEMORIAL CHAPEL

Modeled after the Hagia Sophia in Istanbul, Turkey, the chapel's stunning interior is decorated with 10 million pieces of marble, colored stone and glass, which designer Charles Lamb procured with the help of six craftsmen from the Vatican, who came to Minnesota to create the mosaic. Prominent architect Harry "Wild" Jones designed the round Byzantine Romanesque-style chapel, which was completed in 1910.

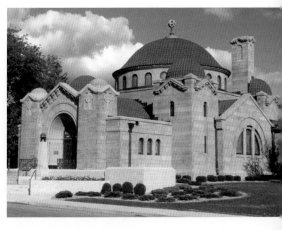

THE LANDING

Nestled on the scenic bank of the Minnesota River, this 88-acre park, formerly known as Murphy's Landing, is a living history village that preserves and interprets what life was like in the Minnesota River Valley during the mid-to-late nineteenth century, with a special emphasis on the Civil War era. Costumed interpreters demonstrate their crafts and explain what life was like when Minnesota was part of the western frontier.

LANDMARK CENTER

This imposing building was completed in 1902 and once served as the Federal Court House for the Upper Midwest and as a post office. The building features an impressive five-story interior courtyard and now serves as a cultural center for music, dance, art, theater, exhibitions, and special events.

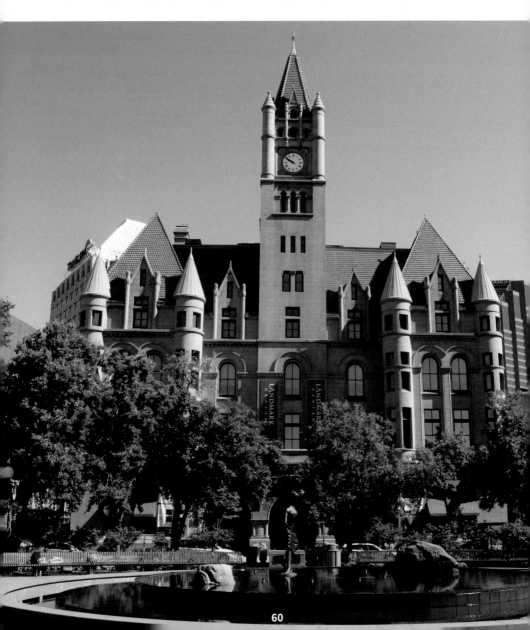

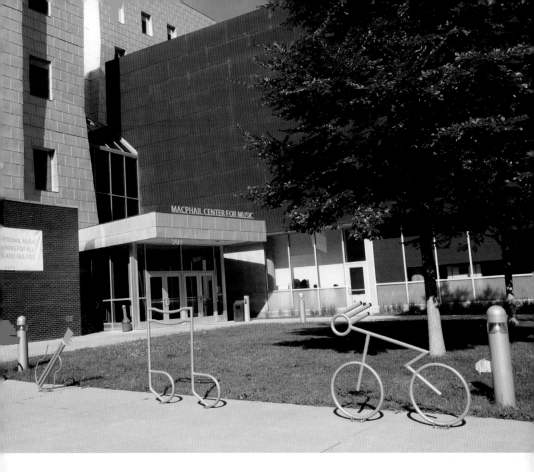

MACPHAIL CENTER FOR MUSIC

Established in 1907 by William S. MacPhail, an original
member of the Minneapolis Symphony, this nonprofit
music education center is now located in the Mill
District of Minneapolis. The school has offerings for all
ages, instruments, and experience levels and serves
over 15,000 music students each year.

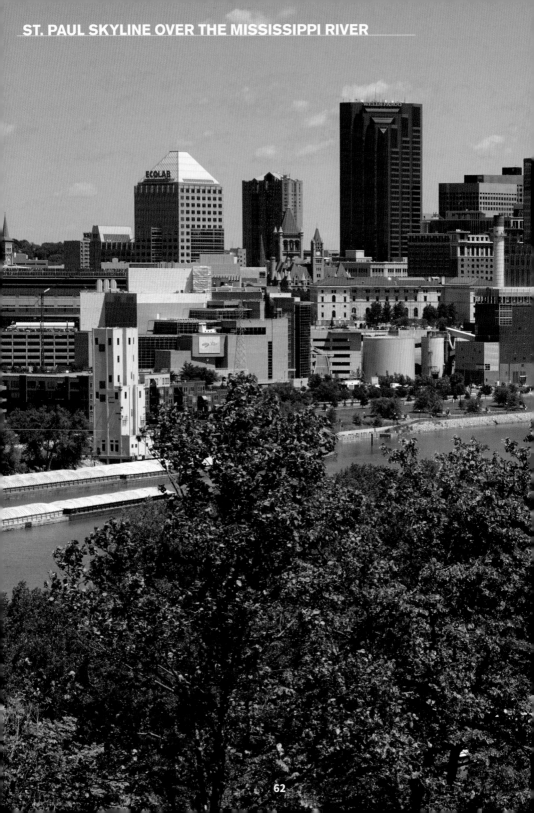

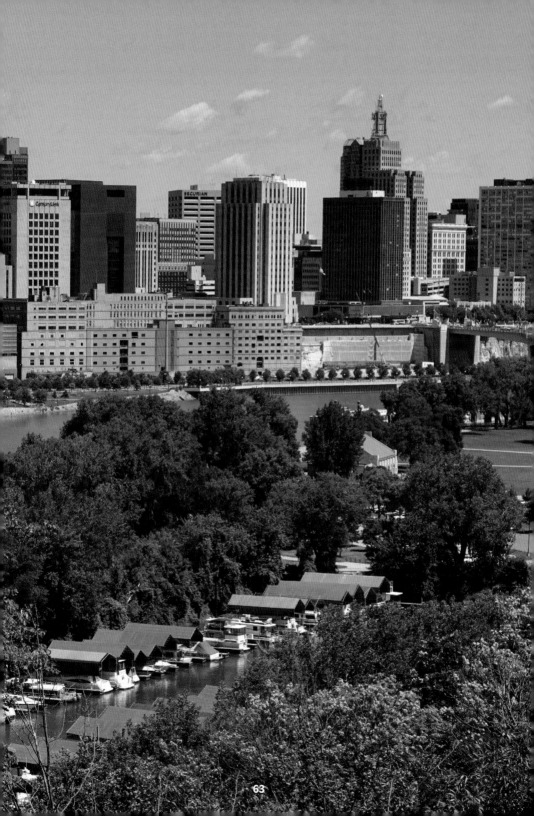

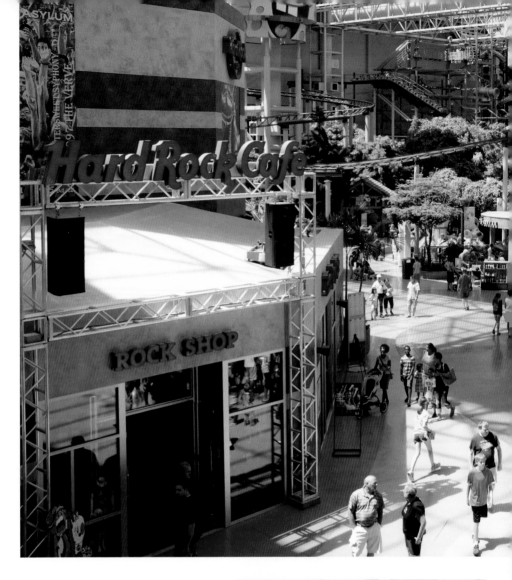

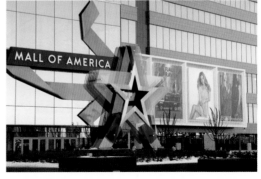

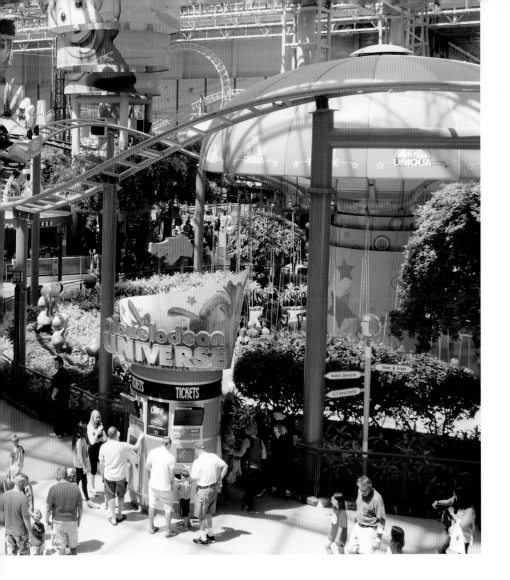

MALL OF AMERICA

Located on the former site of Metropolitan Stadium, where the Vikings and Twins once played, the Mall of America is the largest entertainment and retail complex in the country and welcomes over 40 million visitors annually, which is roughly equivalent to the entire population of Canada. The mall features over 520 stores, a 7-acre theme park, a wedding chapel, two attached hotels, and hosts more than 400 events per year.

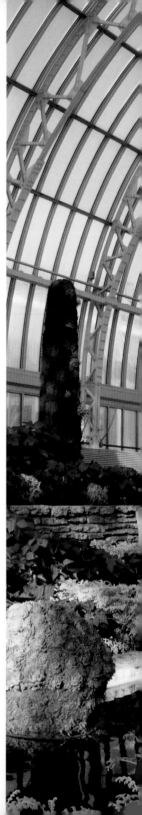

MARJORIE MCNEELY CONSERVATORY

This Victorian-style structure encompasses an entire acre under glass and is home to six indoor gardens, and three that are found outdoors. Opened in 1915, the conservatory includes century-old palms, five seasonal flower shows a year, and a two-story rainforest exhibit. It is named for Marjorie McNeely, the wife of businessman and philanthropist Donald McNeely. Located adjacent to the Como Zoo, the conservatory is open 365 days a year; admission is free.

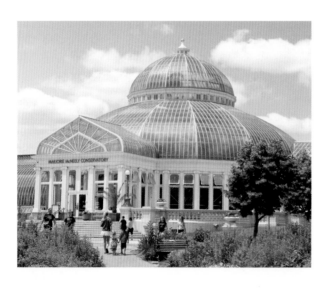

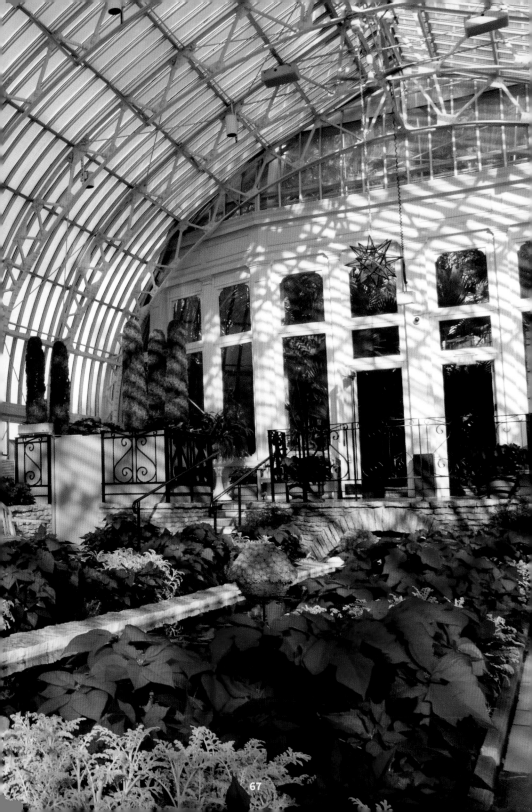

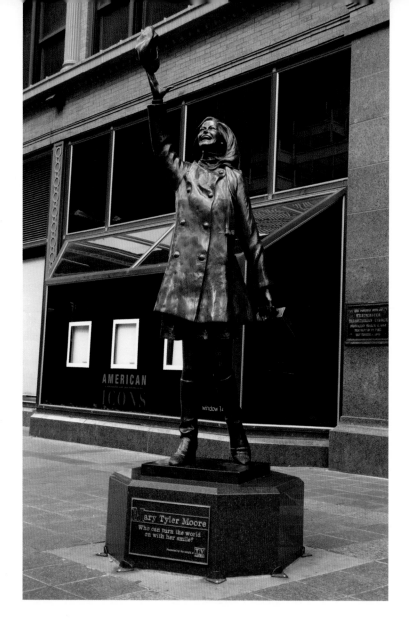

MARY TYLER MOORE STATUE

The 8-foot-tall bronze statue honors Mary Tyler Moore and her beloved TV character, Mary Richards, from the 1970s Emmy Award-winning sitcom—*The Mary Tyler Moore Show*, which was set in Minneapolis. The statue stands at the corner of 7th Street and Nicollet Avenue in downtown Minneapolis, the same spot where Moore joyfully tossed her hat skyward at the beginning of each episode.

METRO TRANSIT LIGHT RAIL

The Twin Cities are home to two light rail routes, which offer affordable, frequent service between downtown Minneapolis, downtown St. Paul, and the Mall of America. Operated by Metro Transit, the 19-station, 12-mile Blue Line and 23-station, 11-mile Green Line opened in 2004 and 2014, respectively and currently carry a total of over 23 million riders annually.

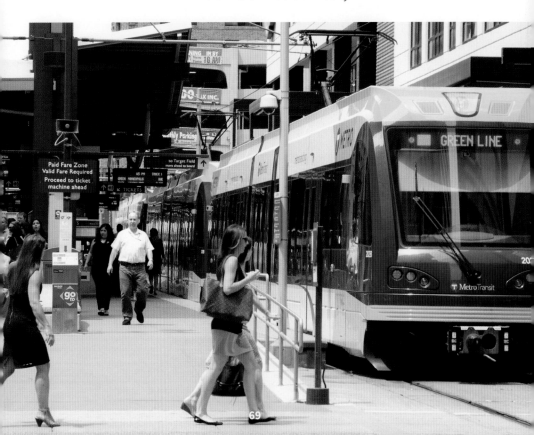

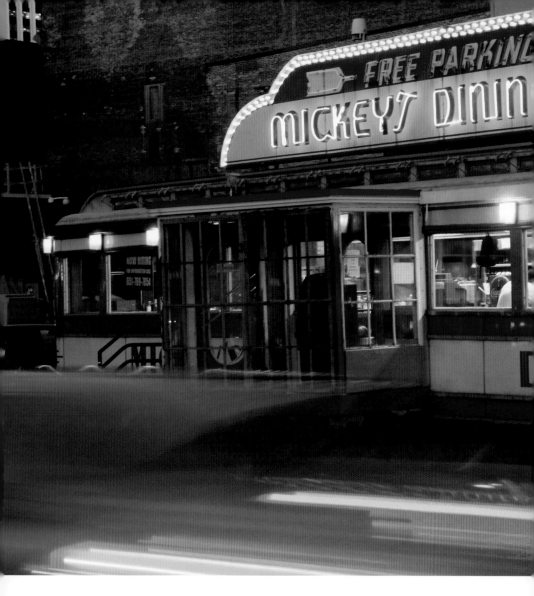

MICKEY'S DINER

This city landmark has been in continuous operation since 1939, and its Art Deco design helped earn it a spot on the National Register of Historic Places in 1983. Featuring delicious homemade meals and known for its all-day/all-night breakfast menu and homemade Mulligan Stew, the diner has been featured on a wide variety of television shows and has been featured in a number of movies, including *Jingle All the Way*, *Mighty Ducks*, and *Prairie Home Companion*.

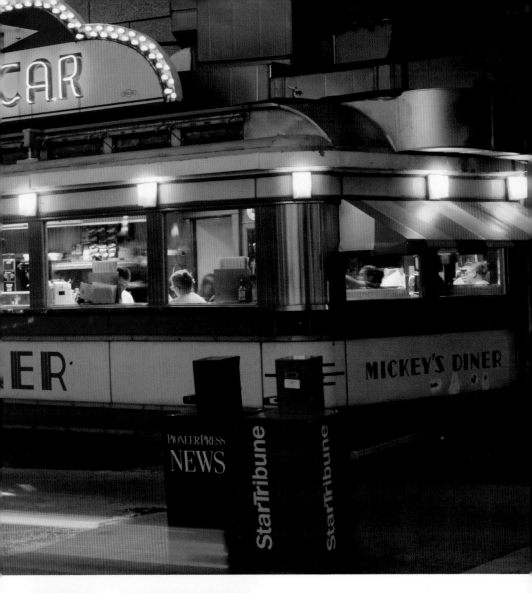

MIDTOWN GLOBAL MARKET

Midtown Global Market is an internationally themed public market featuring a variety of small, independently owned ethnic eateries, shops, specialty grocery stores, and vendors of arts and crafts. It is also home to many community dance and music programs and children's activities. Midtown Global Market occupies part of the ground floor of the old Sears Roebuck building that was built on this site in 1928. Sears closed its doors on December 31, 1994, and the site was redeveloped into a mixed-use building, which opened in June 2006.

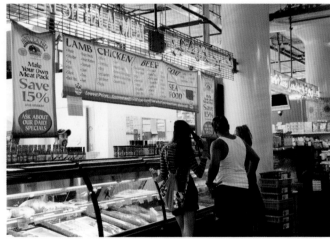

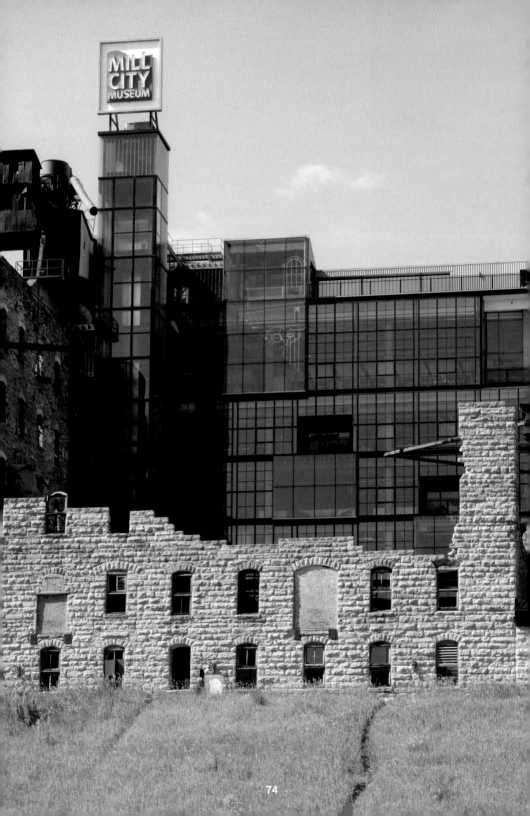

MILL CITY MUSEUM

Rising nine stories above the courtyard of the ruins of the Washburn A Flour Mill that closed in 1965 and was almost destroyed by a fire in 1991, this museum showcases Minneapolis as the flour milling capital of the world from 1880 to 1930. The museum features a hands-on baking lab, an eight-story Flour Tower interactive exhibit, an exhibit gallery, and an observation deck. It also includes exhibits about the infamous Mill Disaster of 1878, which happened here.

MILL RUINS PARK ➤

Opened in 2001 to celebrate the history of the nineteenth-century ruins that were once massive flour mills, this 10-acre park is located on the west side of St. Anthony Falls and is the centerpiece of the revitalization of the West Side Milling District. A walk through the park offers exceptional views of the Stone Arch Bridge, the Mill City Museum, the Guthrie Theater, and the Minneapolis skyline.

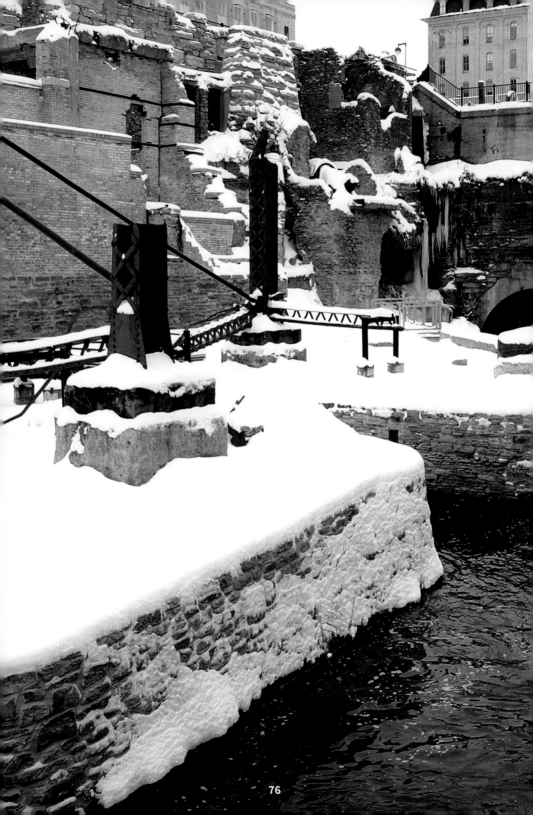

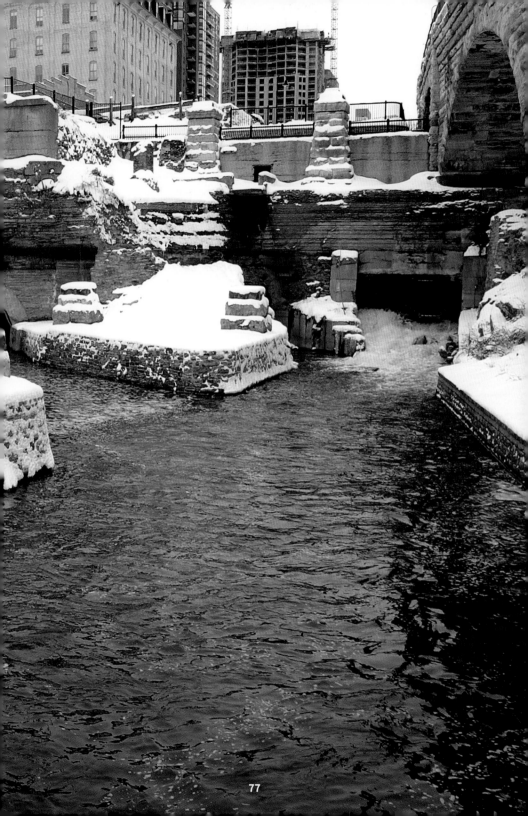

MINNEAPOLIS AQUATENNIAL

First held in 1940, the Aquatennial is a four-day festival held in mid-July. It is one of the most popular summer events in the Twin Cities and features a 5K run, a torchlight parade in downtown Minneapolis, a spectacular fireworks display over the Mississippi River, a water show, and much more.

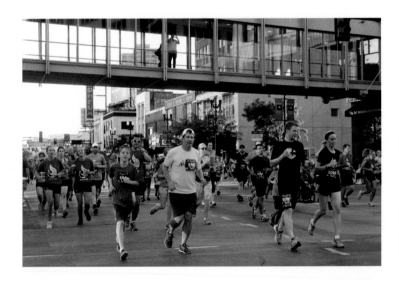

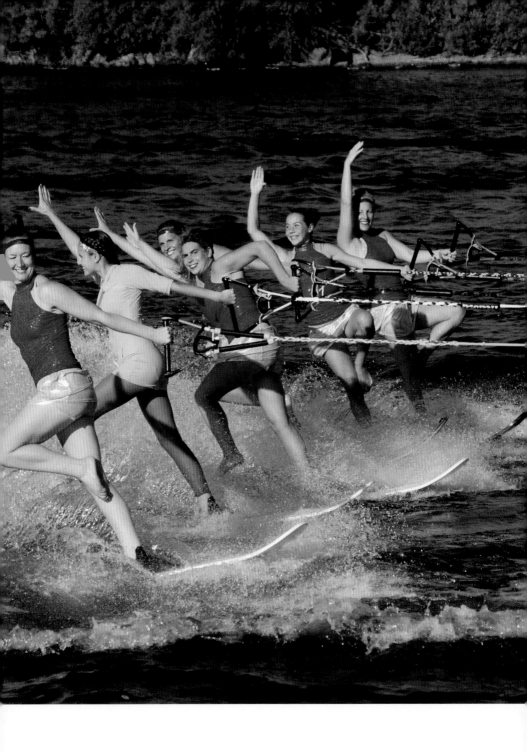

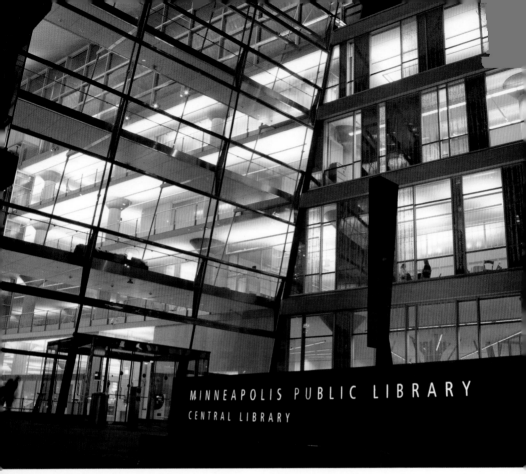

MINNEAPOLIS PUBLIC LIBRARY
CENTRAL LIBRARY

MINNEAPOLIS
CENTRAL LIBRARY

Designed by world-renowned architect Cesar Pelli and completed in 2006, the dazzling new state-of-the-art Central Library is home to more than 2 million books, magazines, pictures, and other documents.

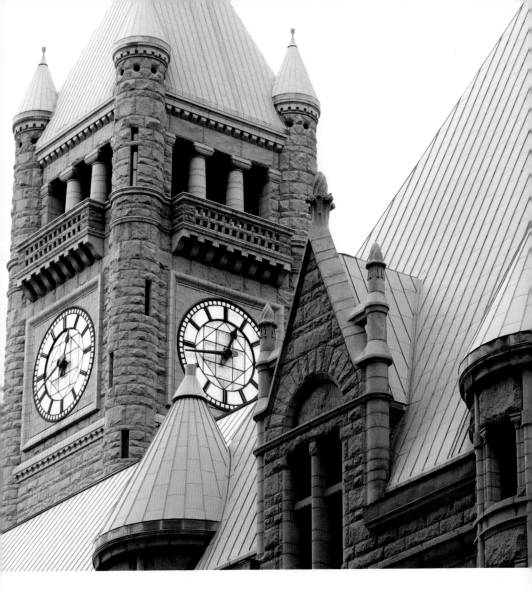

MINNEAPOLIS CITY HALL

An architectural treasure that was added to the National Register of Historic Places in 1974, the 5-story building features a 345-foot clock tower that is one of the largest public timepieces in the world. The Metro Transit Blue and Green light rail lines stop at the Government Plaza station on the south side of the building.

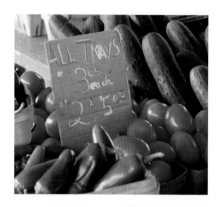

MINNEAPOLIS FARMERS MARKET

Established in 1937 and located at Glenwood and Lyndale avenues near downtown Minneapolis, the market is open seven days a week from mid-April to mid-November and is a source of affordable fresh produce, flowers, baked goods, and a wide array of other products.

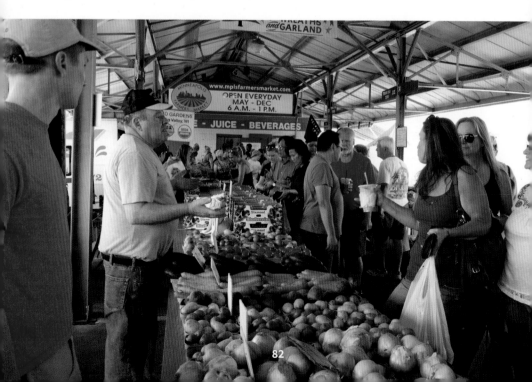

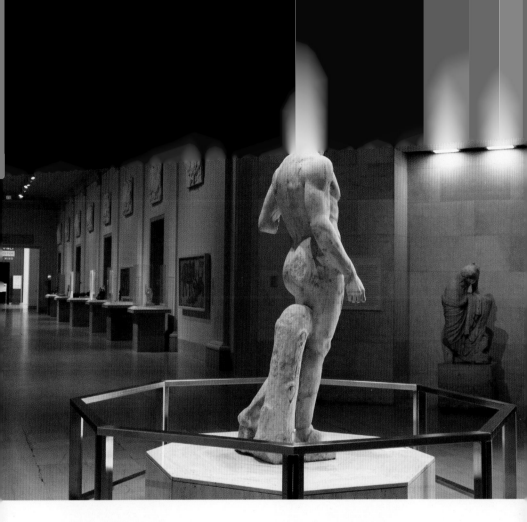

MINNEAPOLIS INSTITUTE OF ART

Founded in 1883, this world-renowned museum is home to over 92,000 objects of art from virtually every part of the world, including European masters and Asian antiquities. Over 700,000 people enjoy the Mia annually, and general admission is free.

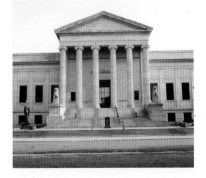

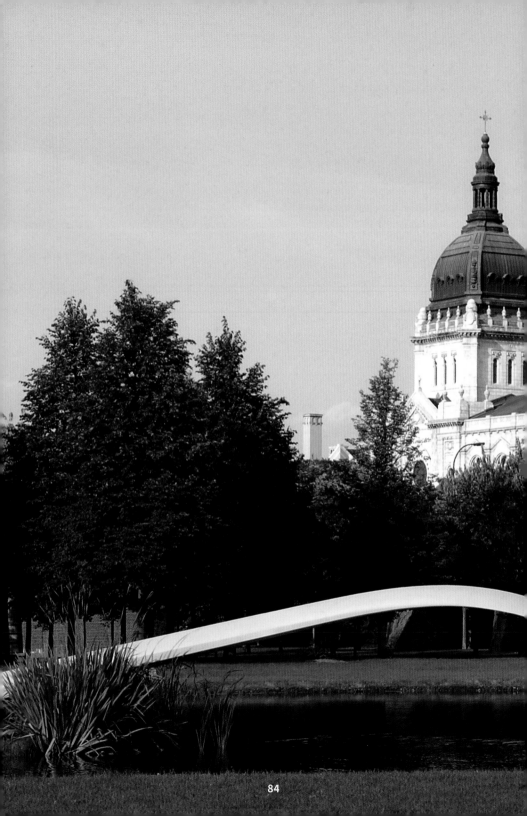

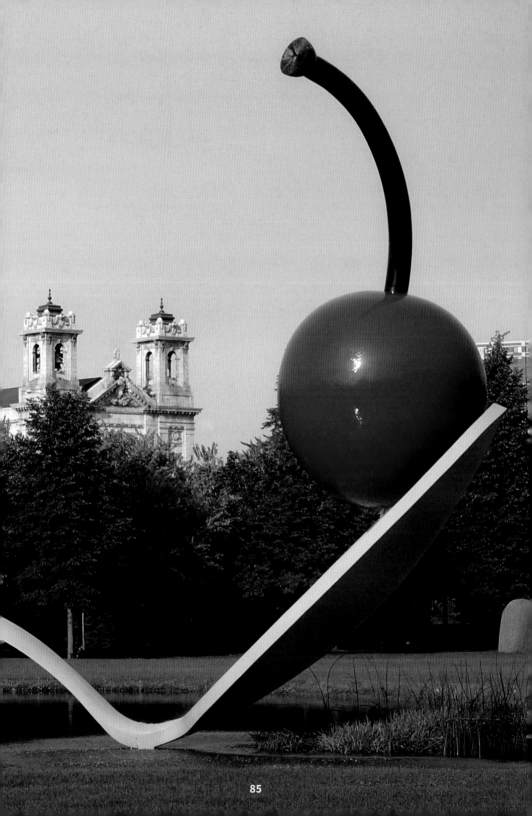

◄ MINNEAPOLIS SCULPTURE GARDEN

Located across from the Walker Art Center, this 19-acre park features 3-dimensional art by leading American and international artists and includes the iconic 55-foot Spoonbridge and Cherry. Recently entirely revamped, it now features 16 new pieces, including a 20-foot-tall sculpture of a giant blue rooster.

MINNEAPOLIS-ST. PAUL INTERNATIONAL AIRPORT

Serving more than 37 million travelers annually, MSP is the nation's 16th-largest airport with around 1.000 commercial flights per day. The two terminals are named for famous Minnesotans, aviator Charles Lindberg and politician Hubert Humphrey. The airport is consistently ranked as one of the best large airports in the country. A new 300-room luxury InterContinental Hotel will open at the airport in 2018.

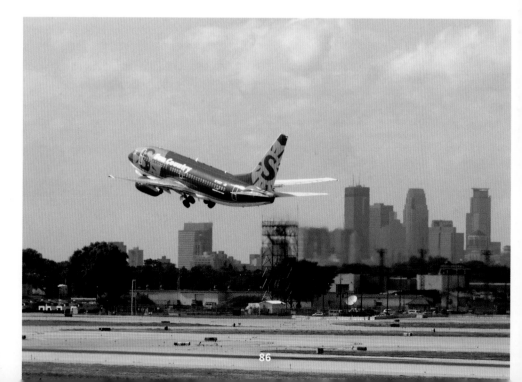

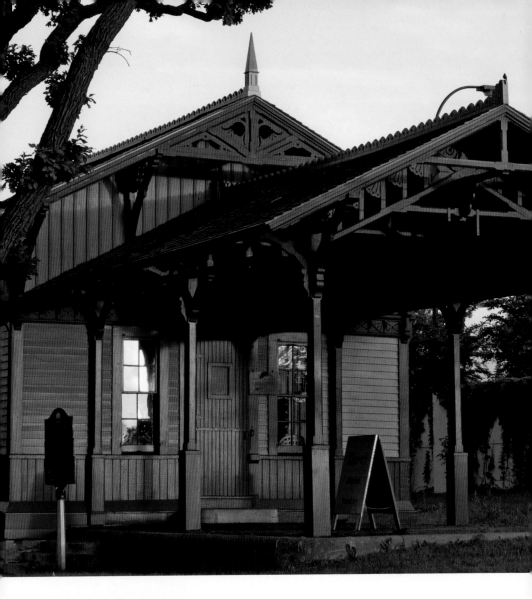

MINNEHAHA DEPOT

Nicknamed "the Princess" for its elaborate architectural features, this small Victorian-style building was built in 1875 and was once a major gateway for travelers arriving in Minneapolis on the Chicago, Milwaukee, St. Paul and Pacific Railroad and was a stop on the first rail link between Chicago and Minneapolis.

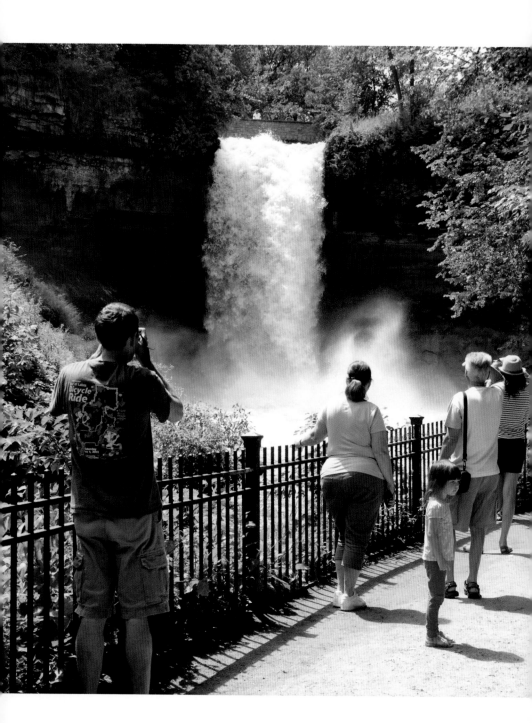

MINNEHAHA PARK AND FALLS

The central feature of this sprawling 170-acre park is Minnehaha Falls, a 53-foot waterfall that gained worldwide fame after Henry Wadsworth Longfellow published his poem "Song of Hiawatha" in 1855. The park features bike rentals, picnic sites, the famous Sea Salt Eatery, playgrounds, walking paths, music, and cultural events, and it's a popular wedding venue.

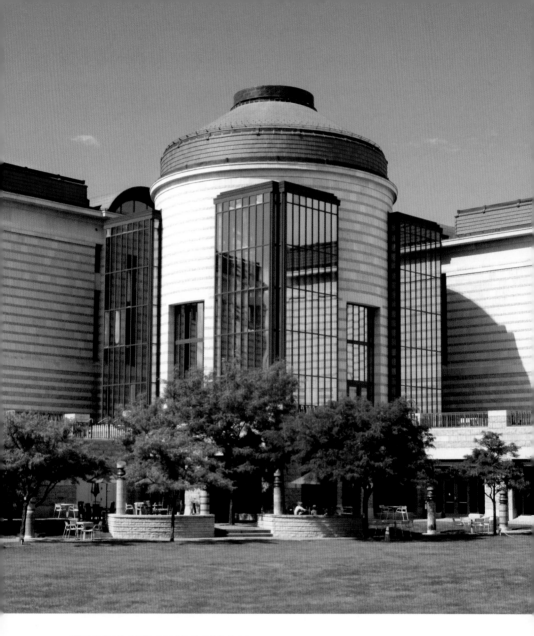

MINNESOTA HISTORY CENTER

The Minnesota History Center houses the largest collection of books, magazines, newspapers, documents, maps, images, and artifacts related to Minnesota history. The center also offers state-of-the-art library services, plus permanent and temporary exhibits.

MINNESOTA LANDSCAPE ARBORETUM

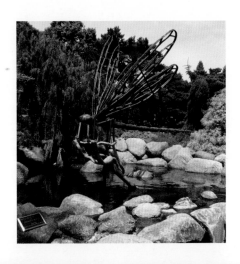

Every season and every visit offers the opportunity to see new beauty in this 1,137-acre horticultural garden and arboretum. Walking trails and a three-mile drive take visitors past many of the collections. Guided tours are also available. *USA Today* named this as one of the top 10 gardens in America.

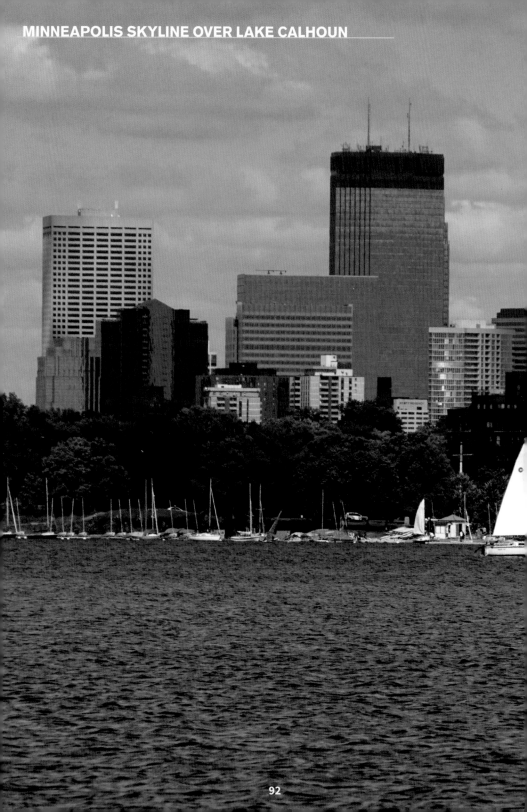

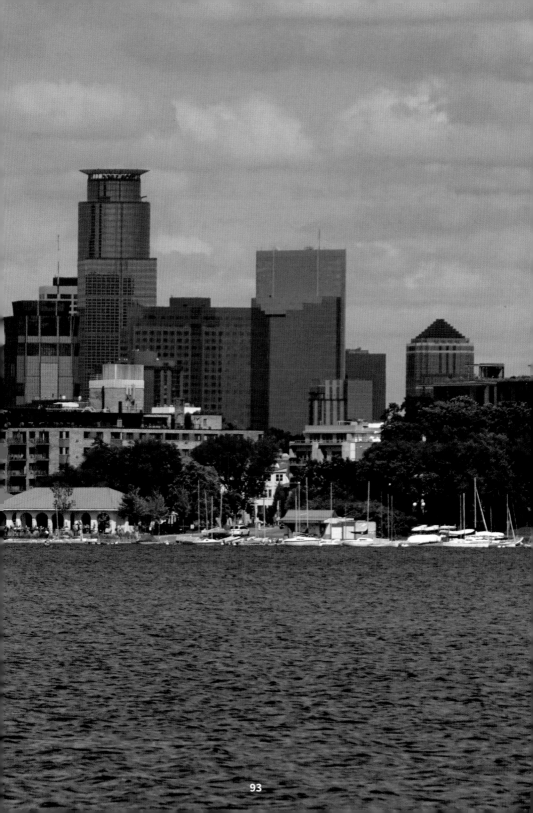

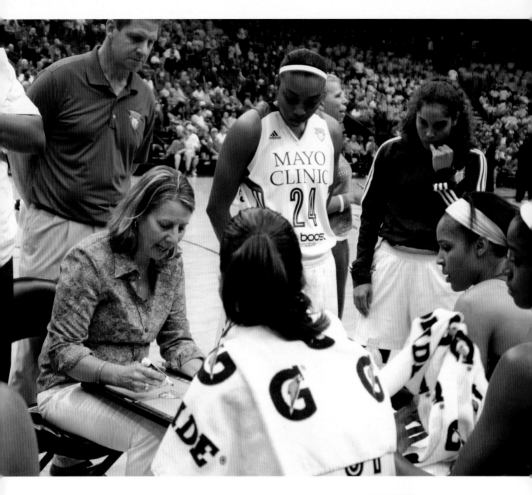

MINNESOTA LYNX

One of two expansion teams added to the WNBA in 1999, the Lynx have won three WNBA championships since 2011 and have played in five championships in the same span. Their roster includes numerous all-stars and Olympic gold medal winners. The Lynx share Target Center in downtown Minneapolis with the Minnesota Timberwolves of the NBA.

MINNESOTA STATE CAPITOL

Designed by nationally renowned architect Cass Gilbert and completed in 1905 at a cost of $4.5 million, the building was modeled after the St. Peter's Basilica in Rome. After more than 100 years of service, Minnesota's premier political landmark underwent a much-deserved 3-year restoration project. Costing $310 million, the updates and restoration work were completed in 2017.

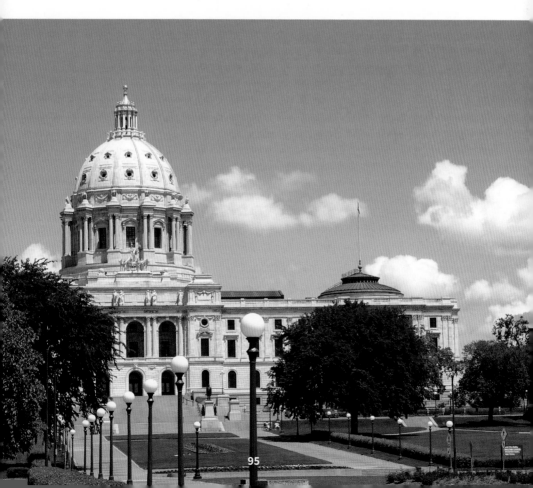

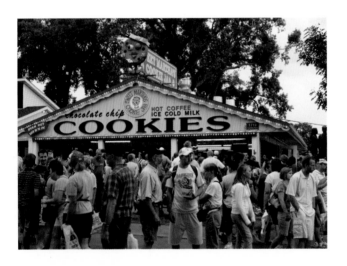

MINNESOTA STATE FAIR

Known as the "Great Minnesota Get-Together," this annual 12-day event ends on Labor Day and is the largest state fair in the country based on average daily attendance regularly, drawing up to 260,000 people per day. The fair is famous for its wide variety of food (often items that are "on a stick"), big-name entertainment at the grandstand, the bustling midway, and its many exhibits and livestock displays.

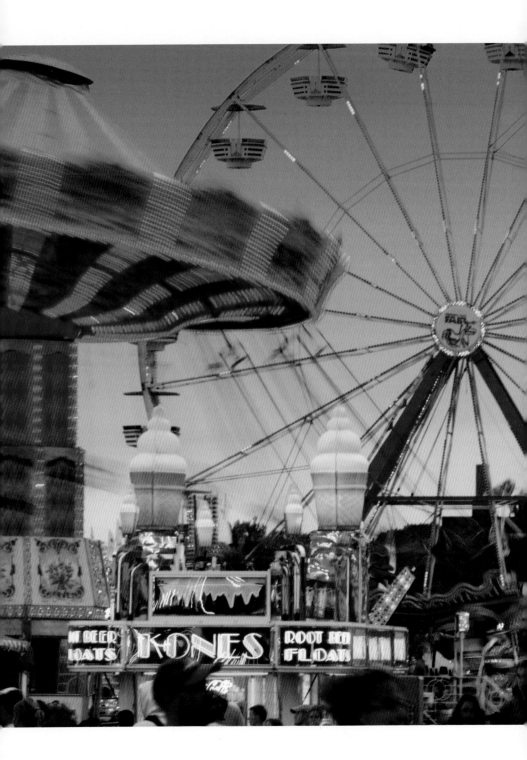

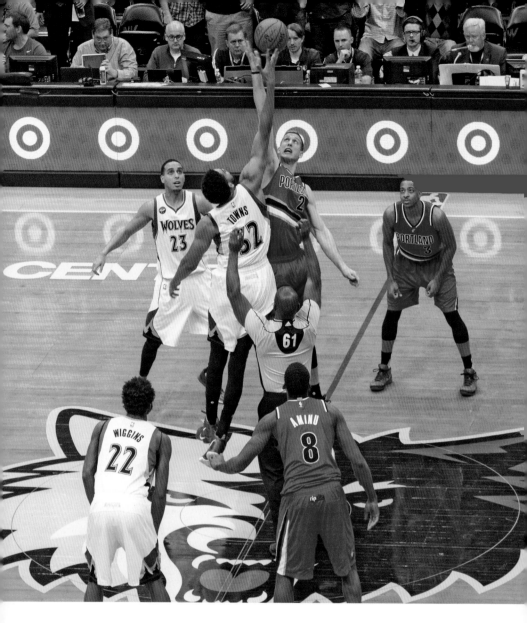

MINNESOTA TIMBERWOLVES

The Minneapolis Lakers relocated to Los Angeles in 1960, but NBA basketball returned to the Twin Cities with the arrival of the Timberwolves in 1989, one of four NBA expansion teams named in 1987. Home games are played at Target Center in downtown Minneapolis.

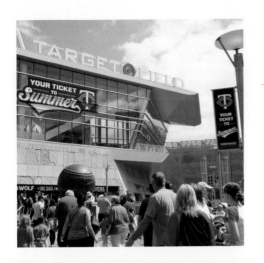

MINNESOTA TWINS

The Minnesota Twins have won six Central Division titles and two World Series Championships, in 1987 and 1991, the latter being considered one of the best World Series of all time. The team plays home games at Target Field, which is located in the Warehouse District of Minneapolis.

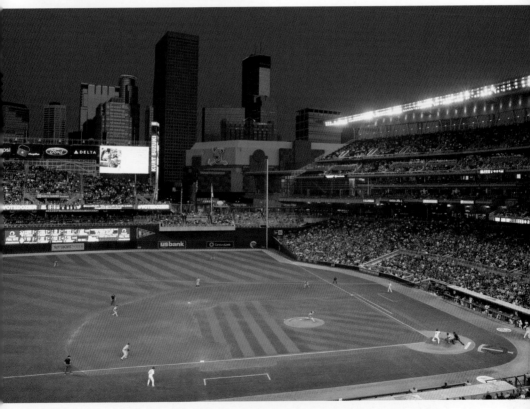

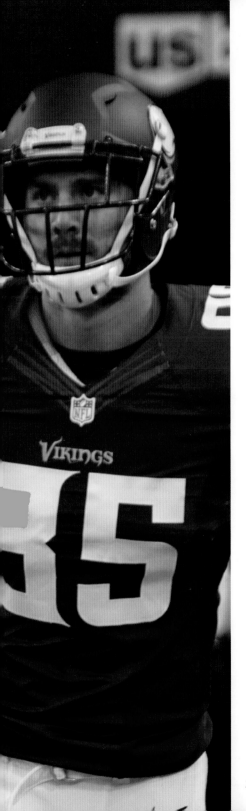

MINNESOTA VIKINGS

Established in 1960 and named to reflect many Minnesotans' Scandinavian ties, the Vikings have been a dominant force in the NFL, winning 19 division titles and playing in 4 Super Bowls, but never winning one. Their fans are among the most colorful and enthusiastic in the NFL. In 2016 the team began playing in the new U.S. Bank Stadium, which cost 1.13 billion dollars.

MINNESOTA WILD

Following the departure of the Minnesota North Stars after the 1993 season, the NHL awarded Minnesota an expansion team in the 2000–2001 season; the team plays at Xcel Energy Center. Of the six professional teams that represent Minnesota, only two—the Wild and Minnesota United FC—play in St. Paul.

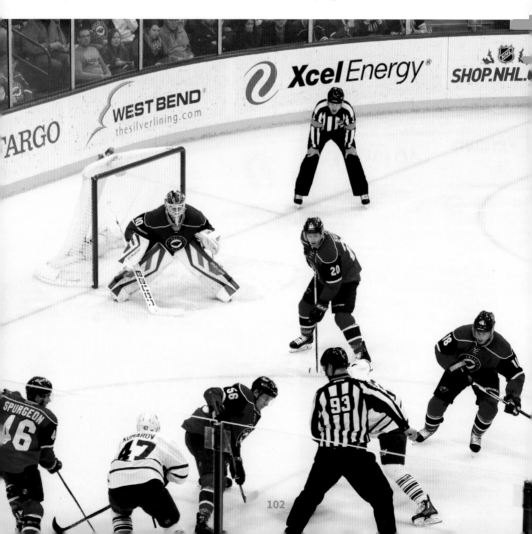

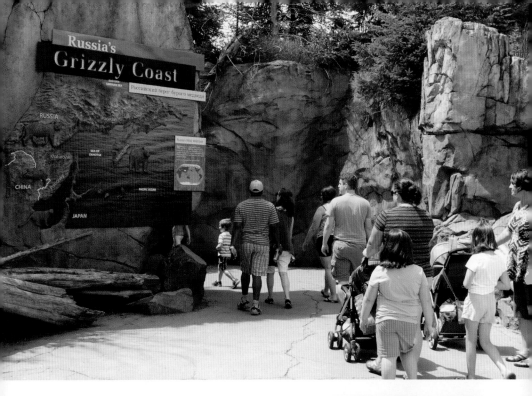

MINNESOTA ZOO

More than 5,300 animals and 540 species reside in this 485-acre zoo that boasts 6 themed areas, which allow visitors to view animals in their natural surroundings. The zoo is open year-round and features a 1,450-seat amphitheater and a 570-seat IMAX theater. The zoo is also a popular spot for concerts, weddings, and numerous annual family-oriented events and attracts over 1.3 million visitors a year.

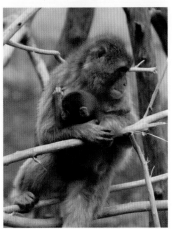

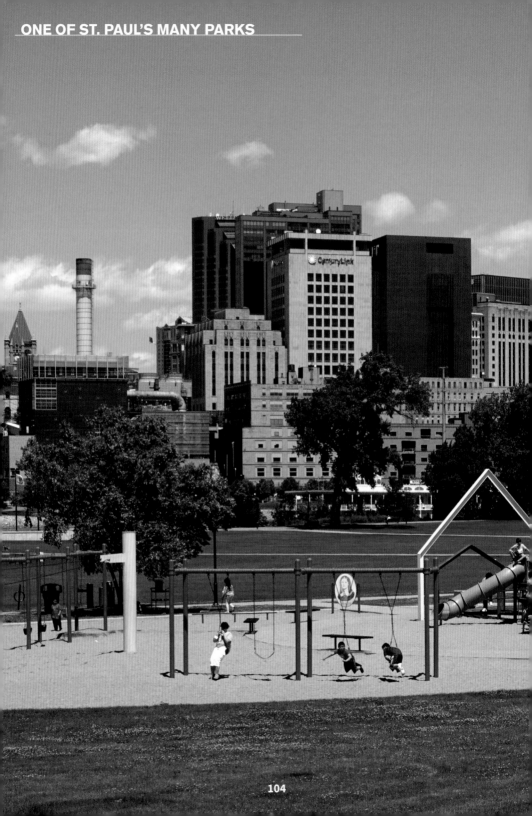

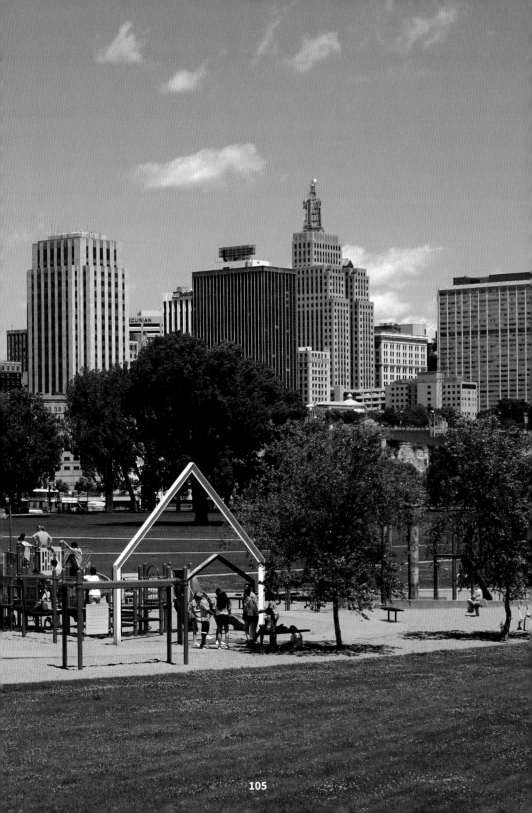

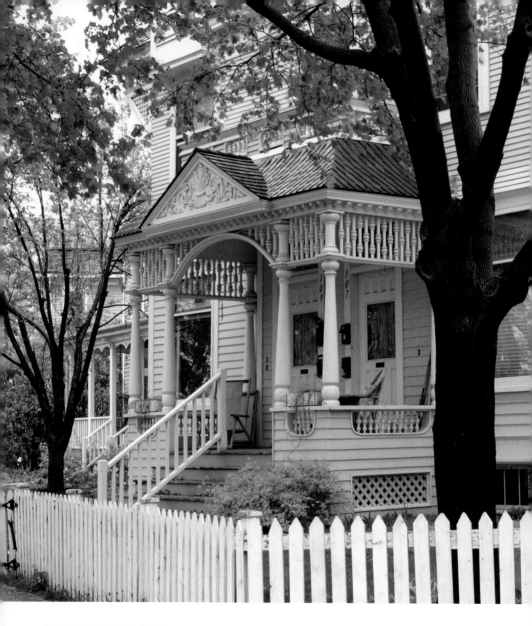

NICOLLET ISLAND

Located at the geographic center of Minneapolis and famous since the 1850s, Nicollet Island is a 48-acre sliver of land surrounded by the Mississippi River. Today it is home to a small enclave of historic Victorian homes, a park and a local high school.

ORCHESTRA HALL

A landmark on the south end of Nicollet Mall since
1974 and one of the most acoustically acclaimed
music venues in the country, Orchestra Hall has hosted
countless world-class performances and is home to
the renowned Minnesota Orchestra. A $52-million
renovation was completed in 2014, doubling the size
of the lobby and public areas. More than 14 million
visitors have attended performances there since it
opened in 1974.

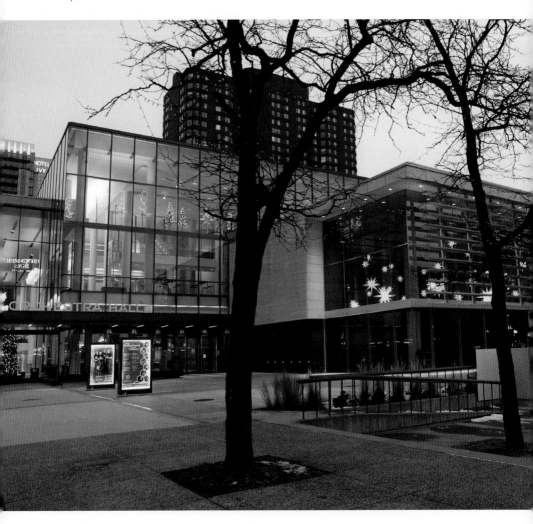

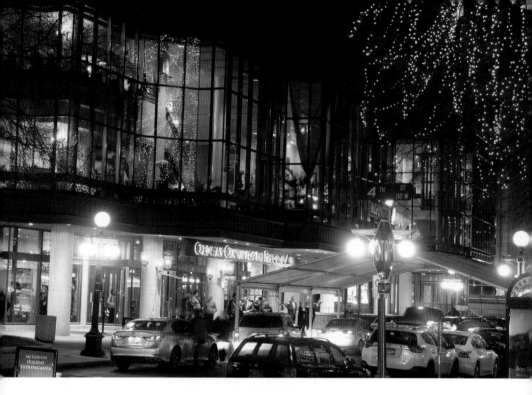

ORDWAY CENTER FOR THE PERFORMING ARTS

Named in honor of Lucius P. Ordway, St. Paul entrepreneur and an early investor and then-president of 3M, the theater opened in 1985 and is a major venue for touring Broadway productions as well as local musical, orchestral, and operatic performances. Internationally known St. Paul architect Benjamin Thompson designed the distinctive building with its three-level windowed lobby.

ORPHEUM THEATER

Opening in 1921 as a vaudeville theater and owned by Bob Dylan from 1979 to 1988, this is the largest of the three historic theaters in downtown Minneapolis. After a $10 million renovation, the theater reopened in 1993 and has hosted performances by top-name entertainers and touring Broadway productions including *Annie*, *The Lion King*, and *Wicked*, among many others.

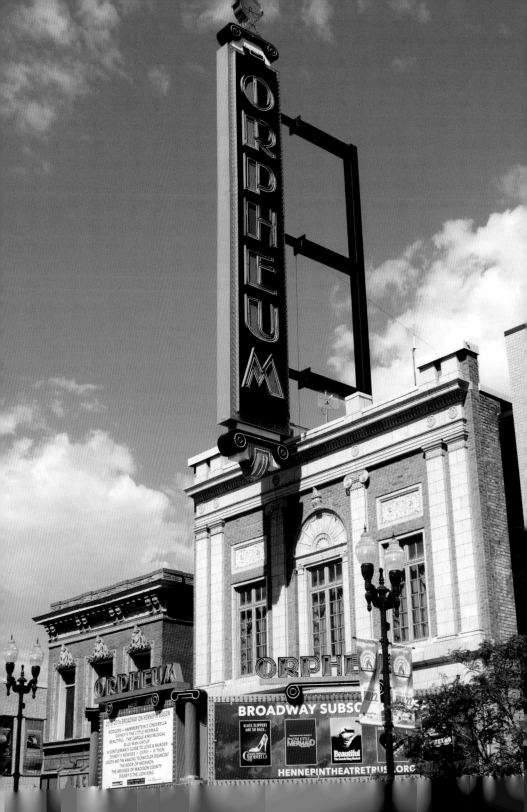

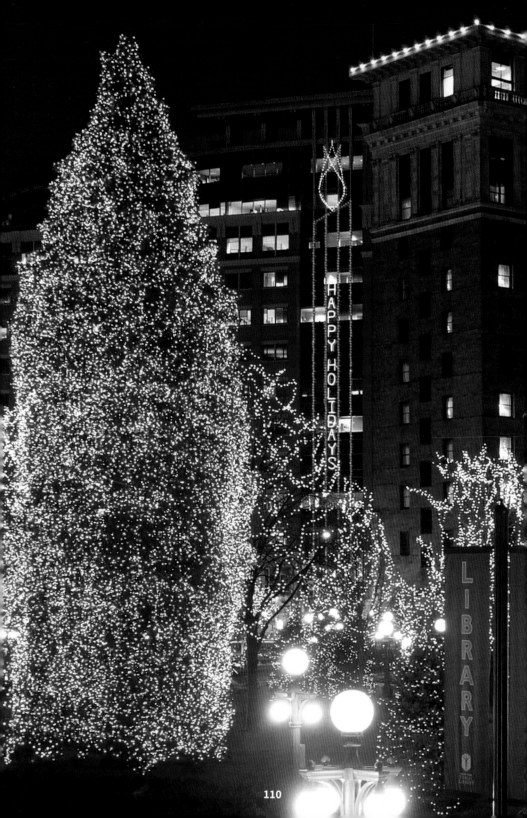

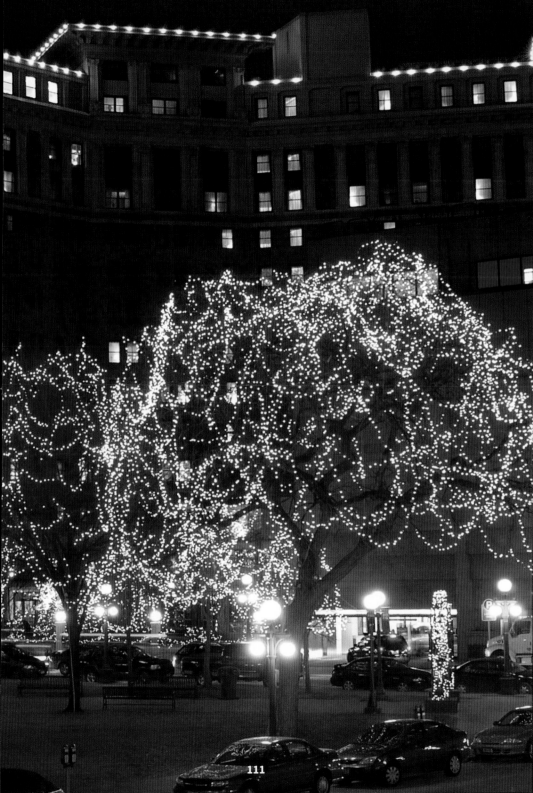

◄ RICE PARK

Surrounded by the St. Paul Central Library, the Landmark Center, the St. Paul Hotel, and the Ordway Theater, this popular public square in St. Paul has been the site of frequent community events, rallies, weddings, and celebrations. During the holiday season, the park is transformed into a winter wonderland of illuminated trees and sculptures.

SCIENCE MUSEUM OF MINNESOTA

Built into the bluffs near downtown St. Paul and overlooking the Mississippi River, this world-class museum attracts nearly 1 million people annually and features permanent interactive exhibits about dinosaurs and fossils, the human body, American Indians, the Mississippi River, and more. There is also a 10,000-square-foot temporary gallery for traveling exhibits and a massive IMAX theater.

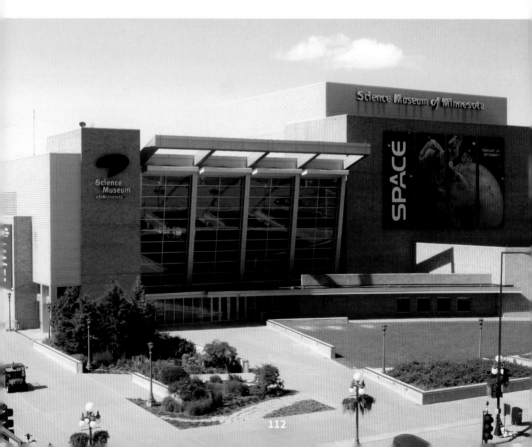

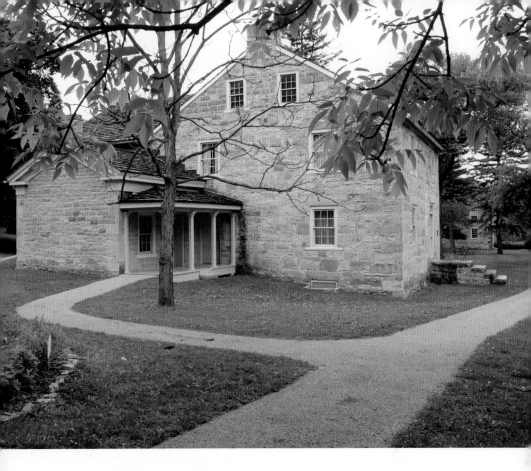

SIBLEY HOUSE HISTORIC SITE

This six-room limestone house in Mendota was built by Henry Hastings Sibley, Minnesota's first governor, between 1835 and 1836 and subsequently served as the governor's residence upon his election in 1858. The house is considered the oldest private residence in Minnesota.

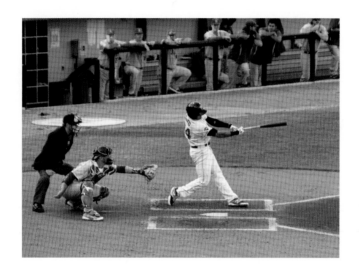

ST. PAUL SAINTS

One of 12 teams in the American Association of Independent Professional Baseball, the St. Paul Saints attract sellout crowds at the new 7,140-seat CHS Stadium, which opened in 2015. The games feature exceptional baseball, reasonably priced tickets, and zany promotions between innings. The team is especially famous for its living mascot, a pig that delivers baseballs to the mound. (There's even a new pig each season.)

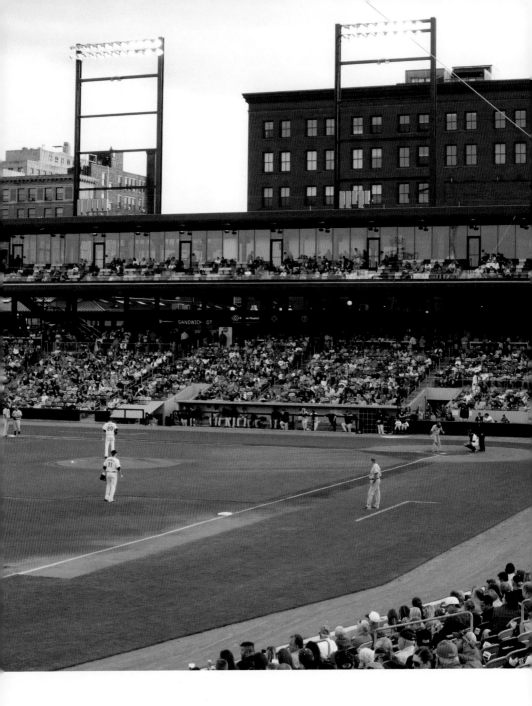

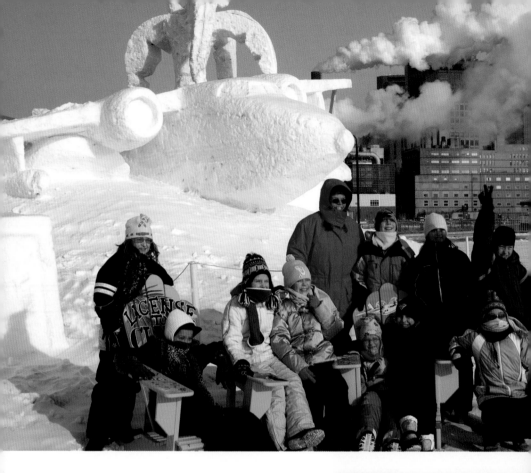

ST. PAUL WINTER CARNIVAL

Started in 1896, the St. Paul Winter Carnival is the oldest winter festival in America and features citywide events such as ice and snow sculptures, wintertime 5Ks, concerts, fireworks, and a $10,000 medallion hunt. The festival lasts for 10 days. It starts the last weekend in January and is attended by over 150,000 people each year.

STATE THEATRE

Built to accommodate both stage productions and movies, this opulent Renaissance Revival-style theater opened in 1921 and was one of the most extravagant theaters in the country at the time. After an extensive renovation, it reopened in 1991 with a production of *Carousel* and was the site of the world premiere of *Grumpy Old Men* in 1993. It commonly hosts Broadway shows such as *Avenue Q*, *Sweeney Todd,* and more.

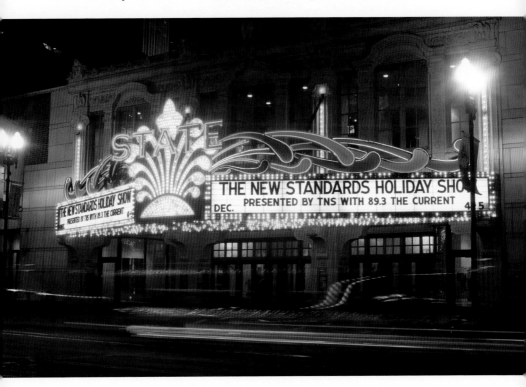

STONE ARCH BRIDGE ➤

Constructed of native granite and limestone, this 2,100-foot-long bridge features 23 graceful arches and crosses the Mississippi River near St. Anthony Falls. Now a symbol of Minneapolis-St. Paul, it was built by railroad baron James J. Hill and opened in 1883. The bridge closed to railroad traffic in 1978 and was reopened in 1994 solely to accommodate pedestrians and bikers.

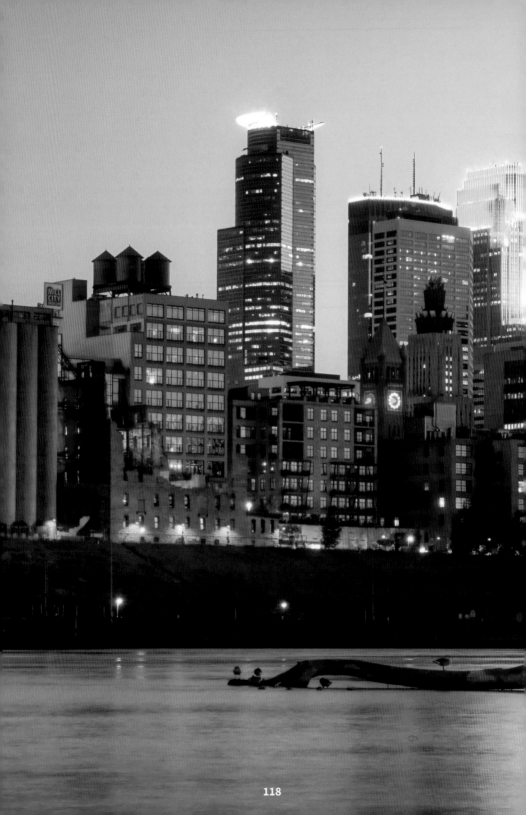

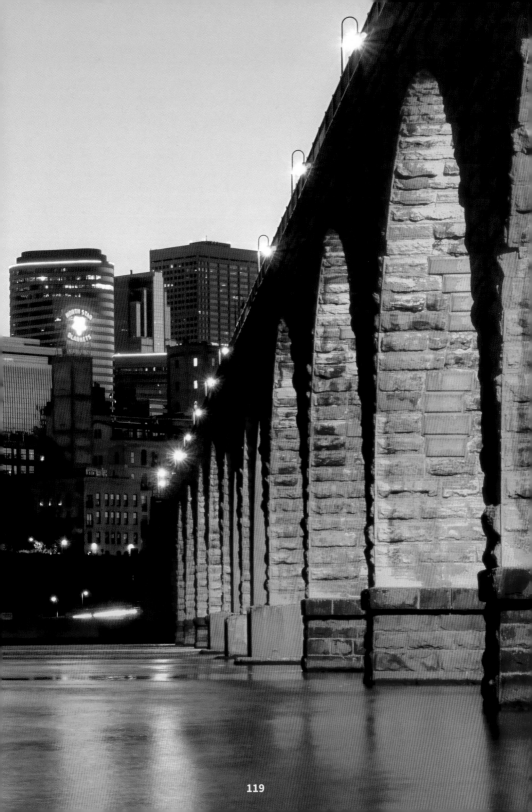

SUMMIT AVENUE

This fashionable, five-mile-long, tree-lined boulevard is the longest stretch of residential Victorian-era architecture in America. It passes a wide variety of famous homes, including the Governor's Mansion and the homes of railroad tycoon James J. Hill and author F. Scott Fitzgerald.

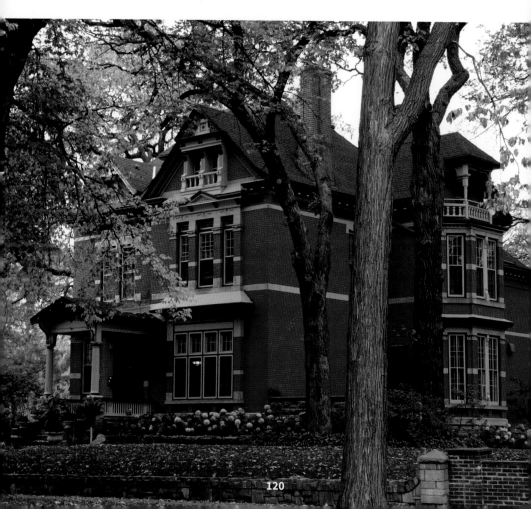

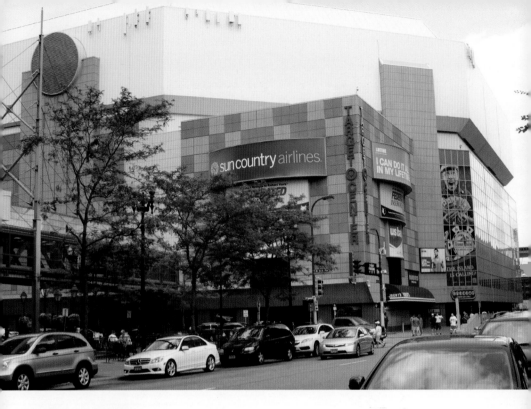

TARGET CENTER

Named for the Minneapolis-based retailing giant, this multiuse arena is home to the Minnesota Timberwolves and Minnesota Lynx basketball teams and also hosts a wide variety and large number of family shows, sporting events, and concerts.

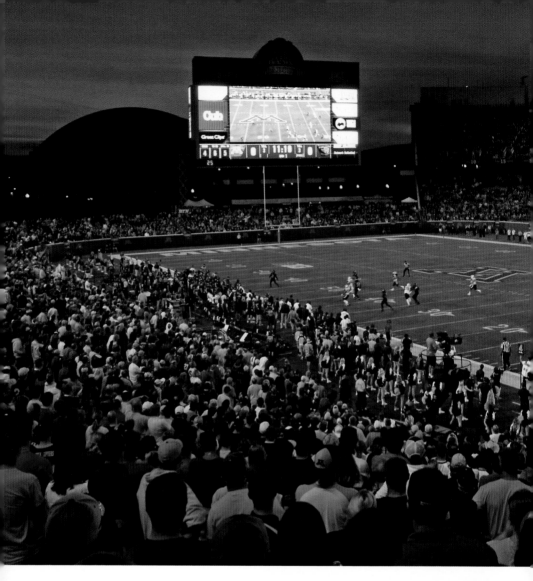

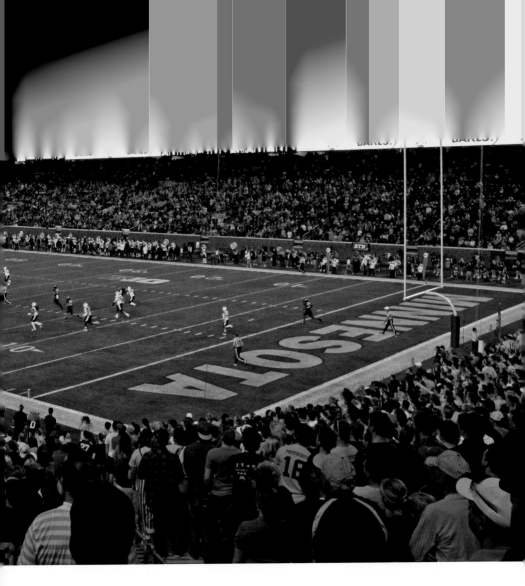

TCF BANK STADIUM

TCF Bank Stadium is the home field for the University of Minnesota Gophers football team and is located on the northeast side of the Minneapolis campus. This horseshoe-shaped outdoor stadium currently seats 50,850 people, and most seats offer stunning views. Construction began in July 2007, and in the first game, played on September 12, 2009, the Gophers beat the Air Force Falcons 20–13. The stadium is also a popular venue for concerts, playing host to U2, the Rolling Stones, Luke Bryan, and Beyoncé.

◄ THEODORE WIRTH PARK

This family-friendly, 740-acre park was named in honor of long-time Minneapolis Park Superintendent, Theodore Wirth. The park offers a treasure of year-round recreational activities, including golf, cross-country skiing, walking and biking, snowboarding, and fishing.

UNIVERSITY OF MINNESOTA

Since the first degrees were granted there in 1873, the University of Minnesota has grown into one of the largest and most comprehensive universities in America with over 51,000 students and more than 150 fields of study.

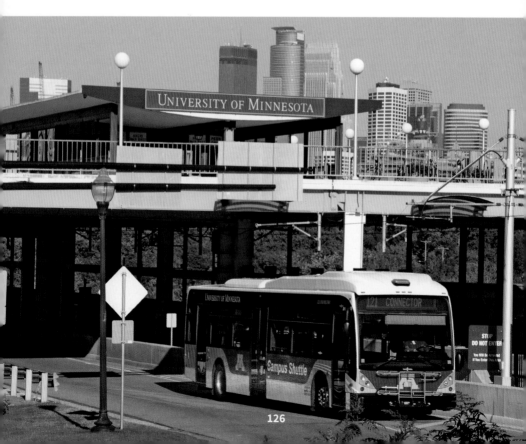

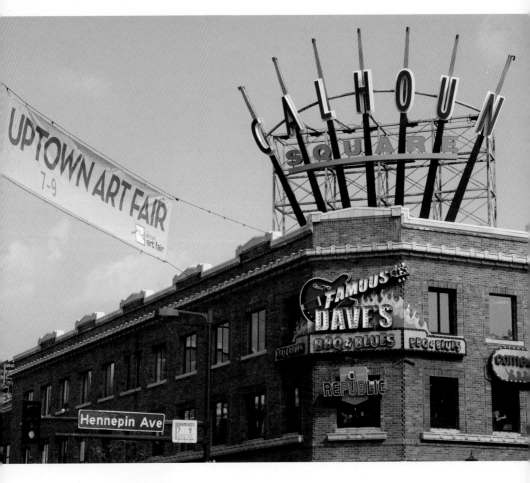

UPTOWN

This trendy, eclectic, and densely populated neighborhood in southwestern Minneapolis is known for its restaurants, nightspots, and specialty stores. Every August, Uptown hosts the nationally acclaimed 3-day Uptown Art Fair, which is attended by more than 400,000 people.

U.S. BANK STADIUM

Located on the site of the now-demolished Hubert .H Humphrey Metrodome, this $1.13 billion, 66,655-seat multipurpose stadium opened with a ribbon-cutting ceremony on July 22, 2016. The first regular-season Vikings home game was played on September 18, 2016, against the Green Bay Packers. Owned and operated by the Minnesota Sports Facilities Authority, the stadium is home to the Minnesota Vikings and is a venue for concerts, conventions, corporate or private events, and other sporting events. It has been chosen as the site of the Summer X Games in 2017 and 2018. It will host Super Bowl LLII in 2018, and the NCAA Final Four in 2019.

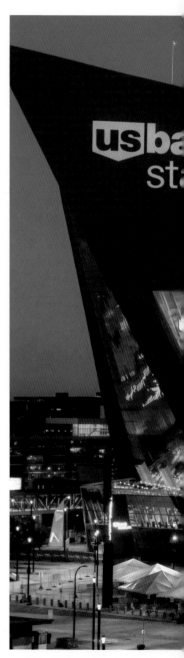

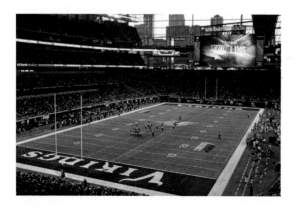

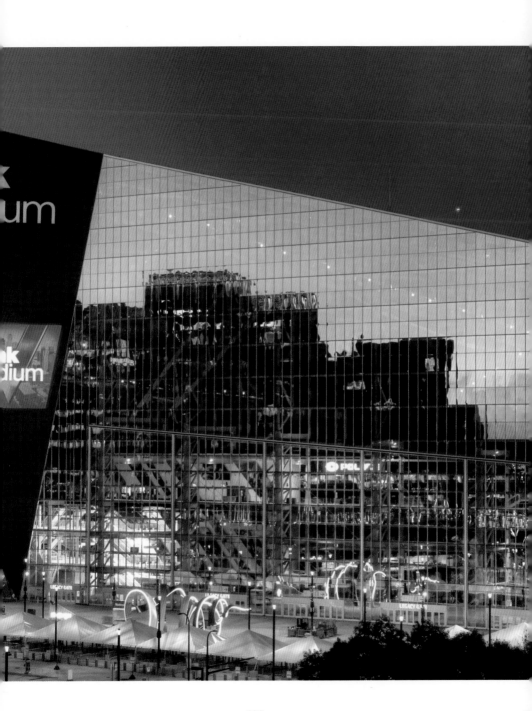

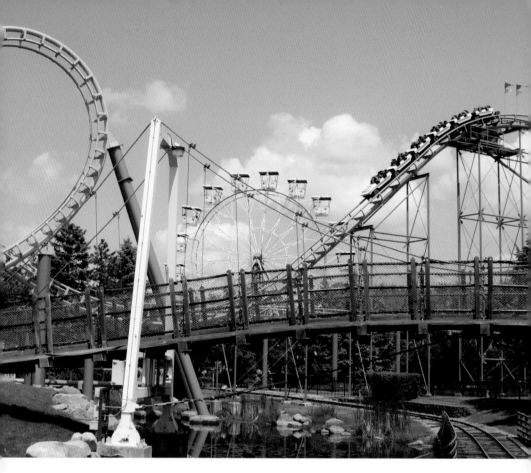

VALLEYFAIR

This 125-acre family amusement park features over 75 rides, including 9 roller coasters as well as a Soak City water park, a carousel, a Ferris wheel, Planet Snoopy, and the new 20-story North Star thrill ride. Throughout the season, Valleyfair offers entertainment packages and hosts special events for families.

WABASHA STREET CAVES

Home to a thriving mushroom farming business in the early 1900s and a subterranean nightclub in the 1920s and 1930s that was said to have been frequented by gangsters, the 12,000-square-foot facility is now an event center, home to a local themed tour company, and hosts nights dedicated to swing music and even offers historic gangster-themed tours.

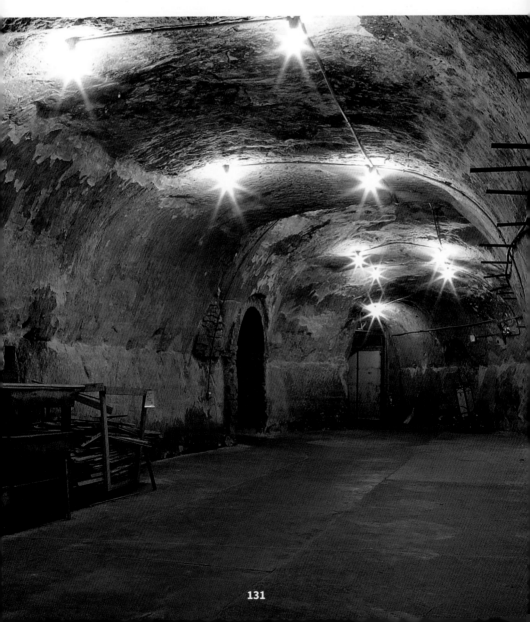

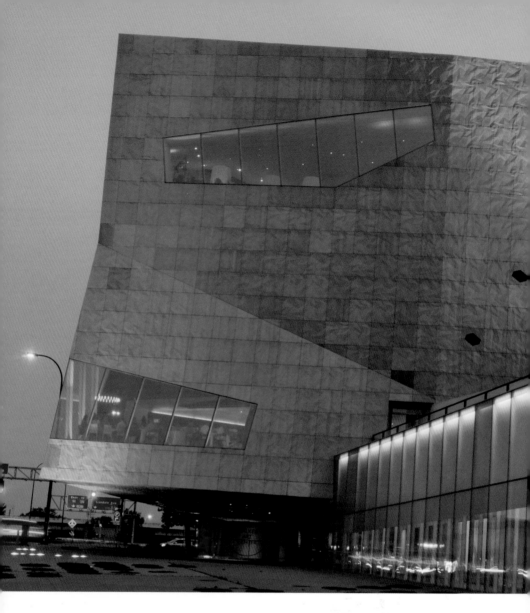

WALKER ART CENTER

Named in honor of the museum's founder, lumber baron and philanthropist Thomas B. Walker, this internationally acclaimed arts venue ranks as one of the most-visited museums dedicated to modern/contemporary art in America. With a collection numbering over 14,000 pieces, the museum—and the adjacent Walker Sculpture Garden (now under construction) attracts over 500,000 visitors annually. The Walker also hosts lectures, classes, and screenings.

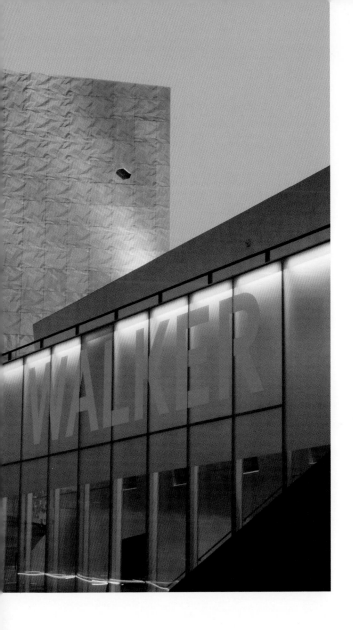

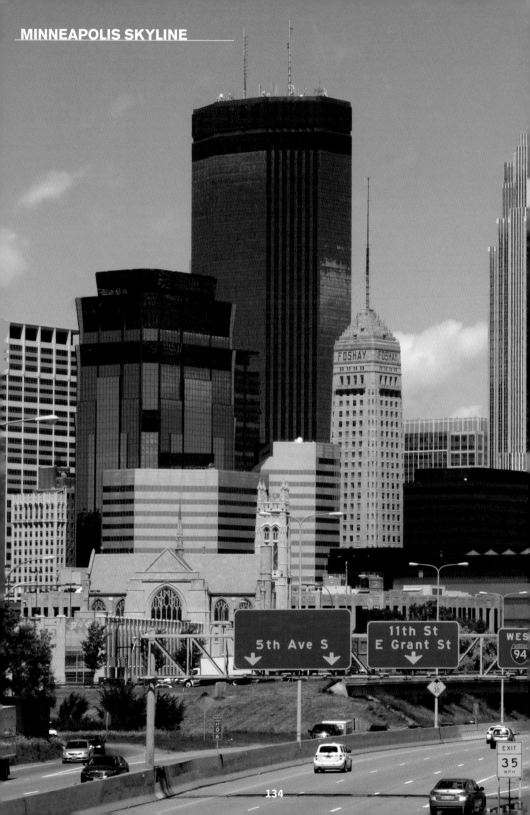

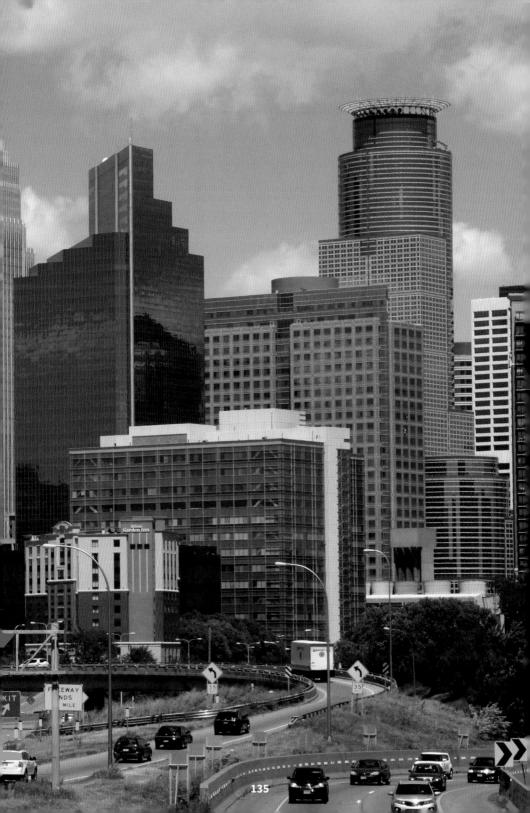

WAYZATA

Just 11 miles west of downtown Minneapolis on the shores of Lake Minnetonka, Wayzata is a vibrant and picturesque community featuring unique shops, exceptional restaurants and bars, salons, and other businesses. The historic Great Northern Train Depot, built in 1906, is one of the city's most popular attractions.

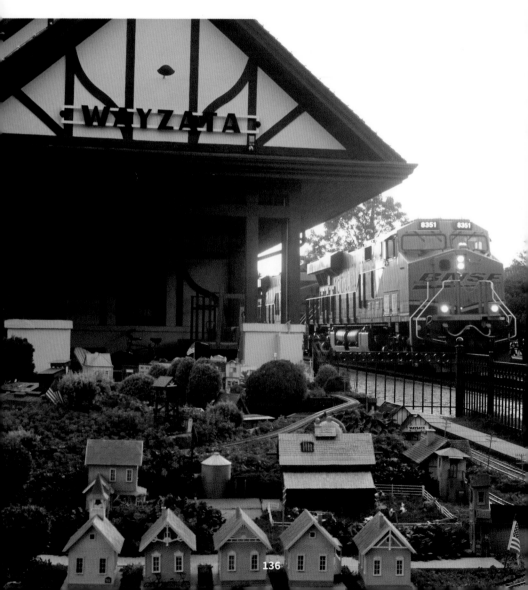

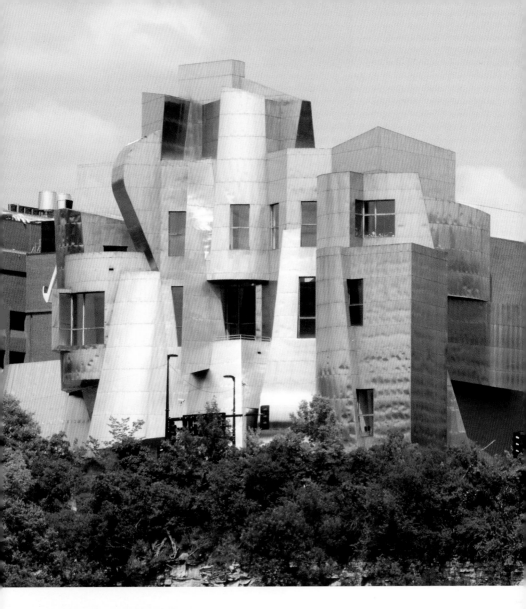

WEISMAN ART MUSEUM

Overlooking the Mississippi River, this unique museum is one of the major landmarks on the University of Minnesota campus. Its architecture features a striking, angular, stainless steel exterior skin designed by noted architect Frank Gehry. Its collection focuses on early twentieth-century American art as well as a diverse selection of contemporary art and American Indian art. Minneapolis businessman and philanthropist Frederick A. Weisman founded the museum and is its namesake.

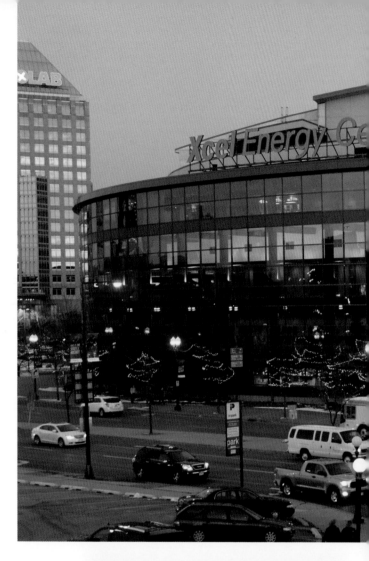

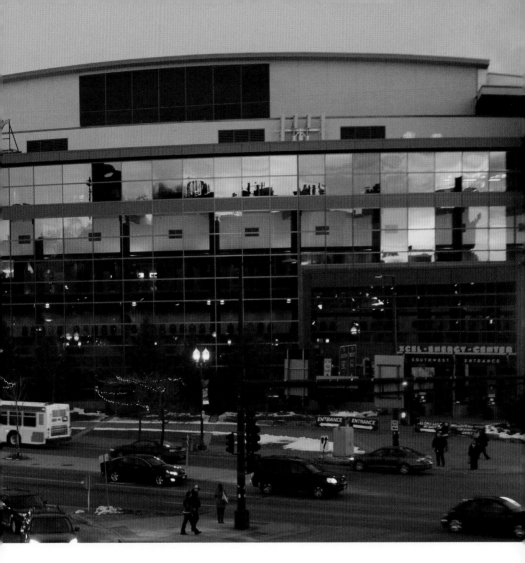

XCEL ENERGY CENTER

This world-class multipurpose sports and entertainment facility opened in 2000 and is home to more than 150 sporting and entertainment events annually, drawing more than 1.7 million visitors each year. In addition to being the home of the Minnesota Wild hockey team, the arena also hosts many conventions, trade shows, and high school athletic tournaments, including the Minnesota State High School League boys' and girls' hockey tournaments, which are essentially must-see TV in the "hockey state."

42	**HARRIET ISLAND REGIONAL PARK**	200 Dr. Justus Ohage Boulevard, St. Paul, 55107; 651-292-7010; www.stpaul.gov/facilities/harriet-island-regional-park
43	**HISTORIC FORT SNELLING**	200 Tower Avenue, St. Paul, 55111; 612-726-1171; www.historicfortsnelling.org
46	**JACKSON STREET ROUNDHOUSE**	193 Pennsylvania Avenue East, St. Paul, 55130; 651-228-0263; www.transportationmuseum.org
48	**JAMES J. HILL HOUSE**	240 Summit Avenue, St. Paul, 55102; 651-297-2555; sites.mnhs.org/historic-sites/james-j-hill-house
49	**JOHN H. STEVENS HOUSE**	4901 Minnehaha Avenue, Minneapolis, 55417; 612-722-2220; www.johnhstevenshouse.org
50	*JONATHAN PADELFORD*	205 Dr. Justus Ohage Boulevard; St. Paul, 55107; 651-227-1100; www.riverrides.com
51	**LAKE CALHOUN**	612-230-6400; www.minneapolisparks.org
52	**LAKE HARRIET**	612-230-6400; www.minneapolisparks.org
53	**LAKE HARRIET-LYNDALE PARK ROSE GARDEN**	4124 Roseway Road, Minneapolis, 55409; 612-230-6400; www.minneapolisparks.org
57	**LAKEWOOD MEMORIAL CHAPEL**	3600 Hennepin Avenue South, Minneapolis, 55408; 612-822-2171; www.lakewoodcemetery.com
59	**THE LANDING**	2187 Highway 101 East, Shakopee, 55379; 763-694-7784; www.threeriversparks.org/parks/the-landing.aspx
60	**LANDMARK CENTER**	75 5th Street West, St. Paul, 55102; 651-292-3233; www.landmarkcenter.org
61	**MACPHAIL CENTER FOR MUSIC**	501 South 2nd Street, Minneapolis, 55401; 612-321-0100; www.macphail.org
65	**MALL OF AMERICA**	60 East Broadway, Bloomington, 55425; 952-883-8800; www.mallofamerica.com
66	**MARJORIE MCNEELEY CONSERVATORY**	1225 Estabrook Drive, St. Paul, 55103; 651-487-8200; www.comozooconservatory.org
68	**MARY TYLER MOORE STATUE**	Corner of 7th Street and Nicollet Mall, Minneapolis, 55402
69	**METRO TRANSIT LIGHT RAIL**	Serves 42 stations on two lines: one between downtown Minneapolis and downtown St. Paul, and one between downtown Minneapolis and the Mall of America; 612-373-3333; www.metrotransit.org
70	**MICKEY'S DINER**	36 7th Street West, St. Paul, 55102; 651-222-5633; www.mickeysdiningcar.com
73	**MIDTOWN GLOBAL MARKET**	920 East Lake Street, Minneapolis, 55407; 612-872-4041; www.midtownglobalmarket.org
75	**MILL CITY MUSEUM**	704 South 2nd Street, Minneapolis, 55401; 612-341-7555; www.millcitymuseum.org
75	**MILL RUINS PARK**	612-230-6400; www.minneapolisparks.org
78	**MINNEAPOLIS AQUATENNIAL**	Various venues throughout Minneapolis; 612-376-7669; www.aquatennial.com
80	**MINNEAPOLIS CENTRAL LIBRARY**	300 Nicollet Mall, Minneapolis, 55401; 612-543-8000; www.hclib.org
81	**MINNEAPOLIS CITY HALL**	350 South 5th Street, Minneapolis, 55415; 612-673-3000; www.minneapolismn.gov
82	**MINNEAPOLIS FARMERS MARKET**	312 East Lyndale Avenue North, Minneapolis, 55405; 612-333-1718; www.mplsfarmersmarket.com

83	**MINNEAPOLIS INSTITUTE OF ART**	2400 3rd Avenue South, Minneapolis, 55404; 612-870-3000; www.artsmia.org
86	**MINNEAPOLIS SCULPTURE GARDEN**	725 Vineland Place, Minneapolis, 55403; 612-375-7600; www.walkerart.org/garden
86	**MINNEAPOLIS-ST. PAUL INTERNATIONAL AIRPORT**	Lindberg Terminal, 4300 Glumack Drive; Humphrey Terminal, 7150 Humphrey Drive, Minneapolis, 55450; 612-726-5555; www.mspairport.com
87	**MINNEHAHA DEPOT**	In Minnehaha Park near Minnehaha Parkway and Highway 55, Minneapolis, 55417; 612-228-0263; www.mnhs.org or www.transpotationmuseum.org
89	**MINNEHAHA PARK AND FALLS**	4801 Minnehaha Drive, Minneapolis, 55417; 612-230-6400; www.minneapolisparks.org
90	**MINNESOTA HISTORY CENTER**	345 West Kellogg Boulevard, St. Paul, 55102; 651-259-3000; www.mnhs.org
91	**MINNESOTA LANDSCAPE ARBORETUM**	3675 Arboretum Drive, Chaska, 55318; 952-443-1400; www.arboretum.umn.edu
94	**MINNESOTA LYNX**	Target Center, 600 North 1st Avenue, Minneapolis, 55403; 612-673-8400; http://lynx.wnba.com
95	**MINNESOTA STATE CAPITOL**	75 Rev. Dr. Martin Luther King Jr. Boulevard, St. Paul, 55155; 651-296-2881; www.mnhs.org/capitol
96	**MINNESOTA STATE FAIR**	1265 Snelling Avenue North, St. Paul, 55108; 651-288-4400; www.mnstatefair.org
98	**MINNESOTA TIMBERWOLVES**	600 North 1st Avenue, Minneapolis, 55403; 612-673-1600; www.timberwolves.com
99	**MINNESOTA TWINS**	1 Twins Way, Minneapolis, 55403; 612-659-3400; www.mlb.com/twins
101	**MINNESOTA VIKINGS**	401 Chicago Avenue South, Minneapolis, 55415; 952-828-6500; www.vikings.com
102	**MINNESOTA WILD**	Xcel Energy Center, 199 W Kellogg Boulevard, St Paul, 55102; 651-222-9453; www.wild.com
103	**MINNESOTA ZOO**	13000 Zoo Boulevard, Apple Valley, 55124; 952-431-9200; www.mnzoo.org
106	**NICOLLET ISLAND**	612-230-6400; www.minneapolisparks.org
107	**ORCHESTRA HALL**	1111 Nicollet Mall, Minneapolis, 55403; 612-371-5600; www.minnesotaorchestra.org
108	**ORDWAY CENTER FOR THE PERFORMING ARTS**	345 Washington Street, St. Paul, 55102; 651-224-4222; www.ordway.org
108	**ORPHEUM THEATRE**	910 Hennepin Avenue, Minneapolis, 55403; 612-339-7007; www.hennepintheatretrust.org
112	**RICE PARK**	109 West 4th Street, St. Paul, 55102; 651-266-6400; www.stpaul.gov/facilities/rice-park
112	**SCIENCE MUSEUM OF MINNESOTA**	120 West Kellogg Boulevard, St. Paul, 55102; 651-221-9444; www.smm.org
113	**SIBLEY HOUSE HISTORIC SITE**	1357 Sibley Memorial Highway; Mendota Heights, 55120; 651-452-1596; www.mnhs.org/sibley
114	**ST. PAUL SAINTS**	360 North Broadway, St. Paul, 55101; 651-664-6659; www.saintsbaseball.com
116	**ST. PAUL WINTER CARNIVAL**	Various venues throughout St. Paul; 651-223-7400; www.wintercarnival.com

117	**STATE THEATRE**	805 Hennepin Avenue, Minneapolis, 55402; 612-339-7007; www.hennepintheatretrust.org
117	**STONE ARCH BRIDGE**	100 Portland Avenue South, east of St. Anthony Falls between the 3rd Avenue and I-35W bridges; Minneapolis; 612-230-6400; www.stonearchbridge.com or www.minneapolisparks.org/parks
120	**SUMMIT AVENUE**	Just west of downtown St. Paul. For a guided walking tour, contact the Minnesota Historical Society; 651-259-3300; www.mnhs.org
121	**TARGET CENTER**	600 North 1st Avenue; Minneapolis, 55403; 612-673-1300; www.targetcenter.com
123	**TCF BANK STADIUM**	420 Southeast 23rd Avenue, Minneapolis, MN 55455; 612-624-5072; www.gophersports.com/facilities/tcf-bank-stadium.html
126	**THEODORE WIRTH PARK**	1339 Theodore Wirth Parkway, Minneapolis, 55411; 612-230-6400; www.minneapolisparks.org
126	**UNIVERSITY OF MINNESOTA**	100 Church Street Southeast; 612-625-5000; www.umn.edu
127	**UPTOWN**	Lake Street & Hennepin Avenue, Minneapolis
128	**U.S. BANK STADIUM**	401 Chicago Avenue, Minneapolis, 55415; 612-777-8700; www.usbankstadium.com
130	**VALLEYFAIR**	1 Valleyfair Drive, Shakopee, 55379; 952-445-7600; www.valleyfair.com
131	**WABASHA STREET CAVES**	215 Wabasha Street South, St. Paul, 55107; 651-224-1191; www.wabashastreetcaves.com
132	**WALKER ART CENTER**	725 Vineland Place, Minneapolis, 55403; 612-375-7600; www.walkerart.org
136	**WAYZATA**	13 miles west on Highway 394 from downtown Minneapolis; 952-473-9595; www.wayzata.org
137	**WEISMAN ART MUSEUM**	333 East River Parkway, Minneapolis, 55455; 612-625-9494; www.weisman.umn.edu
139	**XCEL ENERGY CENTER**	199 West Kellogg Boulevard, St. Paul, 55102; 651-265-4800; www.xcelenergycenter.com

ABOUT THE AUTHOR

A native of Minneapolis and graduate of Washburn High School and the University of Wisconsin-Madison, Gregg Felsen has been a professional photographer and writer for more than twenty-five years.

His articles and photos have been published in such magazines as *Mpls/St. Paul*, *Palm Springs Life*, *Biography*, and *Guest Life Monterey Bay*. This is Felsen's fourth published book and second book about the Twin Cities.

In addition to working on books, Felsen concentrates his efforts on photography of social, corporate, and fundraising events; trade shows and conferences; family and individual photography; vintage motorcars; historical sites in Minnesota; and landscapes. He is a member of Professional Photographers of America and Meet Minneapolis.

Find out more about Gregg or contact him at Gregg@greggfelsenphotography.com and visit his website, greggfelsenphotography.com